MAKE 'EM LAUGH

....................

MAKE 'EM LAUGH

Short-Term Memories of Longtime Friends

DEBBIE REYNOLDS
AND DORIAN HANNAWAY

wm
WILLIAM MORROW
An Imprint of HarperCollinsPublishers

B REYNOLDS

Photos, unless otherwise credited, are from Debbie Reynolds's personal collection and appear courtesy of the author, or from Photofest, Inc.

HarperCollins books may be purchased for educational, business, or sales promotional use. For information please e-mail the Special Markets Department at SPsales@harpercollins.com.

FIRST EDITION

Designed by Renato Stanisic

Library of Congress Cataloging-in-Publication Data has been applied for.

ISBN 978-0-06-241663-6

15 16 17 18 19 OV/RRD 10 9 8 7 6 5 4 3 2 1

As always, I dedicate this book to my children,
Carrie and Todd,
and to my beautiful granddaughter, Billie Catherine.

Contents

···········

FOREWORD

by Carrie Fisher

My mother has many extraordinary qualities, but the one I am concerning myself with here is her willingness to be ridiculous. She's not only willing, she has the ability to shift into the ridiculous at ten thousand paces and put it to good use before anyone else has even noticed—an unmistakable sense of the absurd which at times is so powerful that many have considered attempting to use it to kill weeds.

From my mother (and good neighbor) I learned what has proven to be the most valuable coping skill available to modern man (that is, if that contemporary guy is anything like me). So valuable I used it to introduce my show *Wishful Drinking*. And that skill boils down to this:

"If my life wasn't funny, it would just be true and that's unacceptable."

My mother may not have used those exact words, but it's been the gist of how she has managed to get through some death-defying life experiences.

One of the biggest laughs we shared occurred the night my brother, Todd, shot himself in the upper thigh—and fortunately no higher—with a blank. My mother called a cab to get him to the hospital (ambulances can be so loud). Once he was settled into his room there, she returned home to the five homicide policemen who were waiting with me to arrest her for possession of an illegal firearm. They hauled the two of us down to the police station to be fingerprinted. I don't need to tell you which finger she gave them to be printed. Finally back home at 6:00 A.M., the press began to come a-knocking.

"Debbie, did you shoot your son to get publicity to re-store your show's disappointing business?"

She looked at me with the eyes of the naughtiest, most successful truant to ever play Broadway in order to pay for her soon-to-be ex-husband's debts. (Still with me?)

"Yes!" she cried gaily through the door—as if agreeing to go to the prom with the star football player instead of answering a question that was everything *but* a question. "I did shoot Todd to improve business, which I hope works because I only have one more child to shoot and I am wish-ing for a long run!"

If I learned nothing else from my mom—and I learned quite a bit, though her sex tips left something to be desired, so to speak—I learned this:

"Life is fucking hilarious—especially when it's not—because that's the only time it truly has to be."

Preface

When you're born on April 1, you take everything with a laugh.

In my 2013 memoir, *Unsinkable*, I wrote about the ups and downs that I've had over the past eight decades. At that time I was still on the road, working many weeks a year. Now I'm taking time for myself, and it feels good.

For this book, I'm going to share with you some of the many fun (and some not so fun) experiences I've had. I live with the ghosts of comedy past, present, and future, and cherish what I remember of those who have gone before. As I rely on my memory for what you'll read in the pages that follow, bear in mind that I do so with the belief that we should never let the facts get in the way of a good story.

In our movie *Singin' in the Rain*, Donald O'Connor has a fantastic number called "Make 'Em Laugh." One of the lines in the song is "Make 'em laugh, make 'em laugh. Don't you know everyone wants to laugh?"

It's a great joy to be an entertainer, something I feel I was born to be. It has given me an extraordinary life. Thanks to all of you who have shared this journey with me.

Now sit back while I tell you about my friends, share some jokes, and have a glass of wine, or six.

And as Groucho Marx used to say, "If you've heard this story before, don't stop me, because I'd like to hear it again."

MAKE 'EM LAUGH

· · · · · · · · · · · · · ·

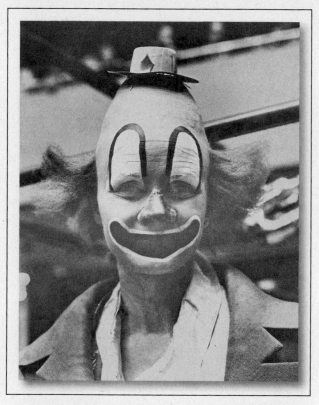

"A little song, a little dance, a little seltzer down your pants."
—CHUCKLES THE CLOWN

When I dressed up to go to a charity party, I gave good clown.

1

·······

A Great Honor

At my age, a surprise can be hazardous to your health.

In the early summer of 2014, I got a phone call from Linda Howard. Her husband, Ken Howard, is the president of the Screen Actors Guild–American Federation of Television and Radio Artists union.

"I'm so excited, Debbie," she said.

"I'm glad you're excited, dear. What's making you so happy?"

"I have a secret," she replied. "But I can't tell you."

That was all I had to hear. I'm not much for guessing games or surprises.

"You've gone this far, Linda," I said. "Don't test my patience. Spill it."

Finally she blurted it out.

"You're getting this year's SAG Lifetime Achievement Award!"

Now it was my turn to be excited. Actually, *stunned* is a better word. I never expected to win any more awards, and I didn't know there was a race for this one.

I thanked Linda and we said our good-byes. The news was officially announced in July. After that, friends kept calling to congratulate me and the reality started to sink in. The awards show was scheduled to take place on January 25, 2015. That seemed like a long time in the future, and I put it out of my mind.

A few years ago, I took a prescription medication for stomach pain. I had a terrible allergic reaction to it that caused my kidneys to shut down. Since then, I've been weak and often get sick to my stomach. I've had every test and seen many doctors, including a two-week stay at the world-famous Mayo Clinic, but no one could figure out what the problem was.

The summer and fall passed quietly. I worked a bit, but enjoyed being at home more. My daughter, Carrie, was in London working on the new *Star Wars* movie. Her daughter, Billie, was with her. I busied myself getting the house updated by adding a new guest room next to my bedroom. It seemed the crew could only work on weekends, and I was awakened Saturday and Sunday mornings by construction noises. I spent a lot of time hiding out in my dressing room/closet, where the noise wasn't as bad, napping in a comfortable chair. By December I was looking forward to the end of construction and getting

through the holidays. I did a voice-over job my agent, Tom Markley, had set up for me, and was happy that I only threw up once.

Then suddenly it was January. The producers of the SAG-AFTRA Awards show were anxious for me to do a lot of interviews, video shoots, and other appearances. The phone rang constantly.

I'm not like a lot of celebrities. Being in the news is not important to me. I've been doing interviews since I was a teenager, more than sixty-five years ago. Most of my life has been spread out across newspaper headlines and magazine covers. I know the value of publicity, but I've done it all so many times, and now I find it exhausting. This time I just wasn't up to it. I was eighty-two years old, and as much as I wanted to help, it takes me a long while to transform from the Frannie Reynolds who naps in her closet to the movie star Debbie Reynolds.

Many of the press people were kind enough to interview me over the phone, which was easy. There were very nice articles in *People* magazine, the *Los Angeles Times*, and *USA Today*.

The SAG-AFTRA Awards ceremony was to take place on a Sunday. The week before was very hectic around the house. Carrie had been asked to present my award to me, and was preparing her speech. Two of my fellow performer friends from New York, Penny Worth and Harvey Evans, flew in for the occasion. Penny had appeared with me on

Broadway, in 1973 and 1974, in *Irene*. Harvey is an actor/dancer who was in the original productions of some of the great Broadway musicals, including *West Side Story*, *Gypsy*, *Follies*, and *Hello, Dolly!* My son, Todd, and his wife, Catherine, came down from their ranch in San Luis Obispo. My granddaughter, Billie, was next door at Carrie's house, with some friends and her adorable cocoa-colored bulldog, Tina.

On Friday night I was feeling terribly ill with stomach problems. Carrie was in one of her manic moods, and decided to take care of me by reading T. S. Eliot poems to me and talking all night while I tried to get some sleep. By six in the morning, I had heard enough to last me for quite a while.

By Saturday afternoon I was so tired I couldn't move. I had to cancel my rehearsal that was scheduled for 4:00 P.M. We let the show's producers know that I wouldn't be there, but Carrie would be. She slept most of the morning, then arrived at the Shrine Auditorium and was met in the parking lot by the crew that she and Todd had hired to film a documentary about our family. They followed Carrie around the rehearsal, filming as she ran through her speech, checked out where we would be sitting on Sunday, and discussed the staging with the director. Then they sat in the limo with Carrie on the ride back. They couldn't film there, because Carrie was in the dark reading selections from her T. S. Eliot book.

Two Vietnamese makeup women were waiting outside when they arrived at Carrie's house. Carrie's assistant had

arranged from the car for them to do Carrie's nails. They all went inside together.

By now I was having dinner—in my bed. My house was full of guests and their pets: Carrie's French bulldog, Gary; Billie's smaller French bulldog, Tina; and Todd's blind and deaf Australian shepherd, Yippee. Catherine usually travels with her pet rooster, Nugget, but thankfully he was off in a coop somewhere. You can tell who's around by which animal is on the loose nearby. At one point, Billie's bulldog rushed into my room like a tornado and ate all of the dog cookies I keep at the foot of my bed. Then she rummaged around, looking for more treats and toys. Todd had to come and take her outside.

Finally everything quieted down a bit, so I could get some rest.

I got up at noon on Sunday. The first thing I did was vomit. After that I was afraid to eat anything, so I just had a little tea. My hairdresser, Pinky, arrived at one o'clock to start styling my wig. I had to get my own hair set and ready. (I use my own hair on the sides and a wig for bangs.) I'd twirl a curl, then toss my cookies.

It wasn't looking good for our Debbie. My lifetime achievement would be getting into my gown.

The documentary crew invaded the house again. They were all over while we were getting ourselves together for the show. When I was ready to get my hair done, I had to wait for the crew to finish interviewing Pinky. Only after

they were done could she come in to help me. It took me four hours to pull myself together. I threw up so many times that I asked my assistant, Donald Light, to put a wastebasket with a plastic trash bag in the car, in case I got sick on the way to the Shrine. I had to deal with a microphone cord under my Spanx, because Todd wanted the crew to record everything during the trip there and back. Spanx can hold in anything, but mine were working overtime.

I don't know how people stand doing reality shows. It's so intrusive having a camera in your face all the time. I'm not concerned with biographies while I'm trying to get ready to receive an award. As far as I was concerned, the crew was in the way and causing too many problems.

The stars were not aligning for me to have a good night.

We'd hired two limos to take us to the Shrine. Carrie, Billie, Todd, Catherine, and I were to ride in one; our friends Penny and Harvey and Margie Duncan; Donald; my accompanist, Joey Singer; and my friend and coauthor, Dori Hannaway, in the other. Everyone was waiting for me in our parking lot so we could get on the road. When I got outside, all the dogs were running around and yapping. Carrie looked beautiful in a black dress with a train everyone kept stepping on.

We left most of the documentary folks behind as we took off for downtown Los Angeles. Two cameramen crammed into the car with us. There wasn't much traffic on the way, but we arrived at the Shrine so late, everyone

was already inside the auditorium. The show had begun. I wanted a picture of Carrie and Billie and me as we got out of the car, but that wasn't possible.

We pulled up at the backstage entrance. I was taken from the stage door to the wardrobe room, where Ret Turner was waiting on the couch that my family had requested for me. Everybody kept asking Ret to get up so I could lie down. Instead we just sat together and talked in order to block out the usual backstage chaos.

I've known Ret for decades. He's one of my favorite designers. I asked him how he was doing, and how his design partner, Bob Mackie, was. Ret asked me if the gold beaded dress I was wearing was one of theirs. I told him it was a copy of one they had done for me years ago. We chatted about our dear friend Mary Ann Mobley, who had recently died. Ret said he'd attended her memorial service in Tennessee. After a few minutes, we were asked to go to our table in the ballroom.

We were seated down front, near the stage. Once in place, I was too sick to enjoy the evening. I was thrilled to receive this honor, but was wondering what I was doing there. The night took on a dreamlike quality. Or maybe I really was in a dream. Everything appeared to be covered in a cloudlike haze.

Joan Collins came over, wearing a glittering black-sequined gown with black satin balloon sleeves and matching elbow-length gloves, a thigh-high slit in the skirt, and

sensible ombré pumps. With her bright red lipstick and perfect long black wig, she looked stunning, as usual. Some other people also stopped by to say hello and take pictures. Reese Witherspoon came over to me. She was adorable, dressed all in white: a doll. My head was spinning just a bit when the production people came to get Carrie to take her onstage to introduce me.

"I am very close to this year's Life Achievement winner," she said. "Not only was my grandmother her mother, she is the grandmother to my alleged daughter. It also turns out that we're neighbors. She's my mother. Actually, she's been more than a mother to me. Not much, but a little bit. She's been an unsolicited stylist, interior decorator, and marriage counselor. Prior to our meeting, she was the voluptuous, fertile half of America's Sweethearts. She was Elizabeth Taylor's maid of honor, a baton twirler, and a French horn player."

Carrie looked beautiful. I couldn't hear what she was saying, but it was well received.

Todd was smiling, so I assumed Carrie was saying something funny.

"She's a movie star, a recording artist, Broadway actor, dance studio owner, preservationist of Hollywood's greatest artifacts, and a cofounder of the Thalians, a group that raised more than thirty million dollars for mental health and related causes."

The audience applauded. I didn't know if it was time to get up or not. Maybe I should get up. The haze closed in.

"Four and a half million of that is allocated just for me," Carrie continued. "She is an extremely kind, generous, and gifted friend who would give you the shirt off her back . . . if Vivien Leigh hadn't worn it in *Gone With the Wind*.

"And it's the Debbie Reynolds of the big screen who made it all possible."

The lights went down as a movie screen was lowered on-stage, film clips began to roll, and a much younger Debbie flickered on the screen. Someone came to the table to lead us to the stage. Billie was on my left side. Todd grasped my right hand. I took a few steps.

Suddenly Birdman appeared before me—Michael Keaton. What a brilliant man he is.

"Hi, Debbie," he said, "I'm here to take your arm."

Now I knew I was in a dream. I looked over his shoulder to see if there was a bird creature behind him. I didn't see any feathers.

"Take both of them," I replied. "They're up for grabs."

I don't know if he heard me, but he was so sweet to take me to the edge of the stage.

Billie and Todd walked me up the stairs and across to Carrie. I stood next to her in the darkness. I couldn't see or hear anything.

The lights came on. Carrie took my hand.

"I am proud to present the Screen Actors Guild Life Achievement Award to my mother, Debbie Reynolds."

The theme from *Singin' in the Rain* began to play. The

audience rose and cheered. I couldn't see anyone but I was thrilled by their warm response. Carrie moved aside so I could speak.

I couldn't find the teleprompter.

I thanked Carrie and Todd, mentioned *Singin' in the Rain*, and proceeded from memory as best I could, under the circumstances.

"I want to thank the Screen Actors Guild for this award. It is very unexpected.

"I've been in the business for sixty-six years. I'm very excited to be here. I had great teachers. L. B. Mayer. Let's not mention Gene Kelly—he was the best in the whole world. I had the best. And I was very excited."

I said that I'd had a good time wearing myself out making *Singin' in the Rain*, and looked at Carrie.

"I had a wonderful hairdo in that movie. Some of you may not remember this, but I had a bun. At the back of my head. A big, ugly bun.

"When my daughter had just gotten a part in a picture, as Princess Leia in *Star Wars*, I said, 'Carrie, be careful of any weird hairdos.' So luckily George [Lucas] gave her two buns. Thank you, George."

Everyone laughed.

"My favorite movie was *The Unsinkable Molly Brown*. I had a lot of fun doing that. In it I got to sing a song, 'I Ain't Down Yet.'

"And I ain't!

"Thank you all for this award."

As the audience cheered me again, Carrie, Todd, and Billie led me off the stage.

Carrie and I went backstage to speak with the press. I barely found a seat; I was so faint. They took my award and put it on a stand so we could be photographed together.

We left right after the press line. I was so happy that things had gone well and everyone seemed pleased. But it was all a blur.

The ride home was bumpy. All I could see on the long journey were clouds and my bed. Everyone had been so wonderful to me, but I was exhausted from all the attention.

The documentary crew was there again when we pulled into the driveway at home.

I went to my door. It was locked. Pinky must have locked it when she left. Nobody had a key. We had to stand outside until the second car arrived so Donald could let us in. Meanwhile, the party planner I had hired couldn't get into the gate and was circling around town.

When we finally got inside, I was out of my gown in record time, into a T-shirt and sweatpants.

Everyone gathered in my living room, drinking and singing. After a few minutes, the documentary crew charged in to film my thoughts about the evening. I managed to say something about how much it meant to me to

be honored by SAG. (It was easier to do that than make a fuss, but I hated the intrusion.) Carrie sat next to me on the couch and spoke about how wonderful the evening was.

After twenty minutes of visiting, I went to bed. I could hear everyone outside my bedroom door, laughing. Joey played the piano while people took turns singing and telling jokes.

When I went to sleep, I knew I wouldn't dream of anything as lovely as getting this award.

What a great honor. I really wish I could have been there.

With Carrie and Todd backstage after my part of the SAG-AFTRA Awards show. Everyone worked so hard to get me through this appearance.
PH: Charley Gallay / Wireimage.com for Turner Entertainment Networks.

With my daughter, Carrie, beside me, I accepted a great honor from SAG-AFTRA—their Lifetime Achievement Award.

PH: Rich Polk / WIreimage.com for Turner Entertainment Networks.

2

·······

The Cinderella Story of the Texas Tomboy

*R*eceiving a lifetime achievement award put me in a reflective mood. The last time I was given a look back at my life and career was in March 1961, when Ralph Edwards surprised me on *This Is Your Life*. I was only twenty-eight at the time.

I'd been asked to tape the presentation of a check for a million dollars from my favorite charity, the Thalians, to Steve Broidy, the head of Cedars of Lebanon and Mount Sinai Hospitals, which had just merged to become Cedars-Sinai Medical Center. The money was for the building of a clinic for the mentally ill at their facility.

My friends told me that the presentation would be broadcast on the news that evening, from the NBC studio in Burbank. We were standing at a podium on the sound stage, chatting in front of a camera while waiting for Mr. Broidy to arrive—me; Hugh O'Brian, the Thalians' first president; Margaret Whiting, the second; the composer

Elmer Bernstein, the current vice president; and, behind me, Jack Haley Jr., the executive vice president. Instead of Mr. Broidy, Mr. Edwards appeared. Ralph always surprised his subjects, and I was no exception. When he told me that I was the one to be the guest that night, I did a pratfall backward into Jack's arms.

We moved across the hall to the *This Is Your Life* set, which included a long couch in the back against a wall of hanging lilac vines and a love seat up front. Ralph escorted me past an urn containing a gorgeous, tall floral arrangement, and had me sit on the love seat as he told the viewers about my life and career. I was a bit overwhelmed when the first person's voice I heard over the sound system was that of my gifted costar from *Susan Slept Here* in 1953, Dick Powell.

Dick entered from backstage. I stood to greet him and we hugged. Dick had always been wonderful to me. He called me a baggy-pants comedian. When we were making our movie together, he taught me a lot about comedic timing and stage kissing. He had such gorgeous blue eyes.

After Dick and I chatted, he went to sit on the long couch behind us. Next Ralph brought out my brother, Bill, and my three uncles, Hugh, Owen, and Wally Harmon. They told everyone what a tomboy I was. They left out the story about how they had dug a hole and buried me alive when I was only a little sprout.

My mother and Daddy came out next with my Grandma Harmon. Mother talked about my earning forty-six merit badges as a Girl Scout.

"Forty-seven, Mother," I corrected her. She must have forgotten the one I got for bird watching.

Daddy told everyone how I'd earned a white Bible for doing work at our church and getting kids to Sunday school in El Paso, Texas. Then he and Grandma talked about our early years there, before we moved to California.

Every few minutes, I wiped away tears as the memories flooded over me.

Next my dear friend Jeanette Johnson came out. Jeanette and I had gone to high school together. We both planned to be gym teachers until my life took a different turn. I would do anything to get attention in those days. I was always in the principal's office for silly stunts like climbing the flagpole. Jeanette told Ralph how I'd sung the loudest and had the biggest mouth of anyone at Girl Scout camp. She was so nervous that she called Ralph "Ruth."

After a break Solly Baiano took the stage. Solly was the talent scout who discovered me at the 1948 Miss Burbank contest. He talked about my early days at Warner Brothers, then MGM. Other friends came on to remind me of my days performing for the troops in Korea.

In the last segment of the show, Ralph asked what November 25, 1960, meant to me. I just stared into space; I

had no idea what he was talking about. Ralph reminded me that it was the day I married Harry Karl. Thank goodness he didn't rub it in that it had been only five months ago!

My second husband entered from the wings with Carrie and Todd. Carrie was very shy as she sat next to me. She was only a little over four years old then, with a cute Buster Brown haircut. Todd had just turned three, and was having fun looking at the TV monitors and saying, "There's Mommy."

Then my friends who'd helped set up this surprise show came onstage: Hugh O'Brian, Margaret Whiting, Elmer Bernstein, and Jack Haley Jr. Hugh explained how the charity had been founded in 1955 to work for the cause of emotionally disturbed children, how Jack had brought me on board, and that I'd been a "real spark plug ever since." Jack mentioned that I'd just been elected president for the third successive year.

As the show closed, I was finally able to present the million-dollar check to Mr. Broidy on behalf of the Thalians. He admitted that he'd been in on the surprise. The show also gave Cedars-Sinai a check for a thousand dollars and a reel-to-reel tape recorder. Ralph gave me a 16mm movie camera and a film of the program as a remembrance. He also gave me a gold bracelet with charms representing special events in my life to that point. Many years later I sold this and some other jewelry to pay for Todd's wedding to his first wife.

At twenty-eight, I still had many adventures ahead of me. There were also quite a few that didn't get mentioned in Ralph's retrospective.

So, with the help of my scrapbooks, old diaries, and my friends and accomplices—here are some of the many things that made me laugh (and sometimes cry) over the years.

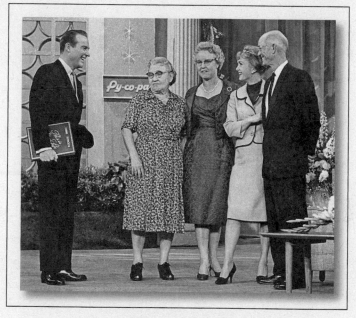

On the set of the popular 1960s TV show This Is Your Life. *The host, Ralph Edwards, had just surprised me. Left to right: Ralph Edwards; Grandma Harmon; my mother, Maxene; and me with my daddy, Ray Reynolds.*

3

······

Early Days

*S*ome of my scrapbooks . . .

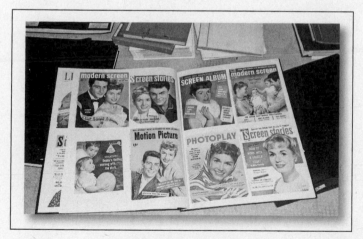

I save almost everything!

In the 1950s hardly a week went by when my picture wasn't in some newspaper or magazine, or both. The same was true for Eddie Fisher, even more so when we got

engaged and the press named us America's Sweethearts. Once when I was still living in Burbank with my parents and Eddie was out of town performing, he sent me a telegram. (That was how you sent special messages in the days before the digital age—or even fax machines!) Eddie's message was signed "Puzzled" and only half serious (I hope), but it shows what we were accustomed to:

JUST PICKED UP A MAGAZINE AND DIDN'T SEE YOUR PICTURE OR MINE EITHER WHAT ARE WE GOING TO DO?

In case you're wondering, telegrams seldom used punctuation.

But before I was a star and my picture was everywhere, there was my first magazine cover.

LASSIE WITH A LASSIE

When I was crowned Miss Burbank in April 1948, there was a flurry of activity surrounding the event. Not only were there talent scouts, one of whom eventually signed me to a studio, there was a lot of local excitement about the contest. I was in parades and other Burbank functions. My picture was in the newspapers in Los Angeles and Burbank.

One day my mother got a phone call from a man who said he was a photographer. He told her that he would like to do a photo shoot with me for a magazine cover. He explained how he would pick me up, drive me to the location, then return me home. She agreed to let him do it.

On a Saturday afternoon, the man pulled up to our house on Evergreen Avenue in Burbank in a station wagon. He had with him a beautiful collie dog. We drove to a remote farm deep in the valley.

It was a pretty uneventful afternoon. The photographer had an outfit for me to wear: a pair of light blue dungarees, a matching blue plaid shirt, a bright red neckerchief, and a white cowgirl hat. I had washed and set my own hair. I wasn't wearing any makeup. (My mother and father didn't approve of makeup for young girls. The only makeup Mother ever wore was a light lipstick called Tangee. There wasn't much color in it; it was orange in the tube but went on almost clear.)

This was the first time I'd ever posed for a picture. All the photos taken of me after I won the beauty contest had been candid shots.

The final picture is of me leaning against a wooden fence next to the collie. It was eventually sold to Collier's, a famous weekly magazine that no longer exists, and appeared on the cover of their November 13, 1948, issue with a box announcing the start of "The Amazing Story of Jimmy

Doolittle" (see color photo insert). By then, I was signed to Warner Brothers. An inside page identified the picture:

> Lassie with a Lassie. Carlyle Blackwell, Jr., son of the famous actor, photographed Debbie Reynolds of Burbank, Cal., after she had won a talent contest.

I think they probably meant to suggest that the collie in the picture was the same dog that had starred in several hit movies in the 1940s, including two with Elizabeth Taylor, and went on to have a hit television series. But the real Lassie never went anywhere without her trainers.

Looking back, I'm amazed that my mother allowed her sixteen-year-old daughter to go off in a car alone with someone she didn't know. She could have asked my brother to go along, but she didn't. She trusted me to be able to take care of myself, and apparently Mr. Blackwell was a very well-known photographer.

...

I was raised on baseball. My father's whole life was about the game. We were not allowed to speak when the radio was on—you did not talk, you did not sing, you did not do anything. You listened to the game. My brother trained to play professionally, but was sidetracked by a shoulder injury. So it was a real event when I was introduced to one of the greatest baseball players of all time.

A HANDSOME, QUIET ADONIS

In the summer of 1952 I was filming *I Love Melvin* in New York City, and one of my publicity trips was to Yankee Stadium to see a game Joe DiMaggio was playing. What a thrill it was to meet him in the Yankee dugout. I believe this picture has never been seen before.

A few years later I was fortunate to meet him socially, when my friend Jeanette Johnson and I were in Paris. Jeanette was a physical education teacher. Sports were her

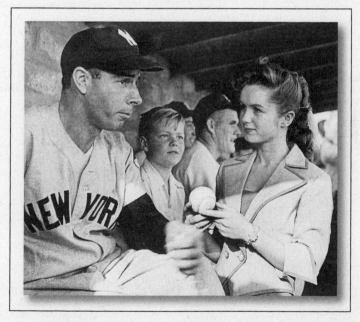

With the great baseball star Joe DiMaggio. I visited him in the Yankees dugout while I was on location in New York making I Love Melvin *with Donald O'Connor.*

passion. On this special evening in Paris, we went out to dinner at Maxim's with the designer Joseph Picone, head of the Evan Picone fashion house, and his wife. They said that a good friend of theirs would be joining us. What a surprise when that friend turned out to be Joe DiMaggio.

I didn't drink at that time, and I'd never known Jeanette to, so when the waiter came over to ask us if we'd like a cocktail, I turned to tell him that she didn't drink. Before I could get the words out of my mouth, Jeanette said, "I'll have a Scotch on the rocks." It was like a vaudeville bit. I was taken aback. Then I realized that she was just getting into the swing of things.

Joe DiMaggio was a quiet, shy man, and so handsome. Jeanette knew his record and all the stats for the Yankees, and that night Joltin' Joe only had eyes for her. Every other beautiful woman at the restaurant must have wondered what her secret was. They talked about baseball the entire night.

So if you want to dazzle a great athlete, learn your stats!

..

When I was under contract to MGM, I was paid every week no matter what I was doing. If I wasn't working on a film, I might be studying dance, singing, or drama. Sometimes the studios sent stars on publicity tours. Once we went to Washington, DC, where we met President Truman; another time Pier Angeli and I toured South America. This is about another trip south of the border.

SWIMMING WITH SHARKS

In December 1952 MGM organized a lavish junket to Mexico City for a visit to their new production studio there, and to attend the inauguration of Mexico's new president, Adolfo Ruiz Cortines. The group included me, Celeste Holm, and Rhonda Fleming and her new husband, Dr. Lewis Morrill. The studio also let me invite my father and my high school friend Jeanette. Celeste and I became good friends on that trip. She was a great gal who liked to have fun. We worked together later in *The Tender Trap* with Frank Sinatra. Celeste was one of our great actresses. She was talented and beautiful, similar in type to Loretta Young. They both had great careers and were nominated for many awards for their work. Celeste won the Oscar, Golden Globe, and New York Film Critics Circle Award in 1947 for her role in *Gentleman's Agreement*, and received two more Oscar nominations after that.

Our first stop was Mexico City. I shivered in the night air. My only coat was at the dry cleaners in LA; I didn't think I'd need it in Mexico. Instead of the usual limo, a bus was sent to pick us up at the airport and take us to the hotel. Some of the actors refused to get on it. I took charge.

"Get on the bus," I ordered them. "You're the luckiest group of people in the world. My father was a brakeman on the railroad. He still works on the road. I worked at the counter at JCPenney. The most fortunate hour of my life

was when I got a job in pictures. On the tenth of this month, I'm going to entertain the troops in Korea. This is the first vacation I've had in two years and nobody is going to ruin it."

Everyone applauded—and got on that bus.

Hedda Hopper, then one of the most powerful gossip columnists in the world, wrote about it. She was famous for her sharp tongue and fabulous hats. She often went along on studio trips. Everyone, including the studios, was afraid of her, although they pretended otherwise. Hedda liked it that way. The studio would never have refused her access, and she in turn provided them with publicity.

(I should say, everyone but me was afraid of her. I always told Hedda when I disagreed with or didn't like something she had written, and she always took it from me.)

The inauguration took place on December 1 at the Palace of Fine Arts, a vast building in the northern part of the city. Masses of people crammed into the huge courtyard to view the proceedings. As we crowded into the room where the ceremony was held, my petticoat started to slip. The elastic in the waistband must have been loose. I tried pulling it up but finally I had to just step out of it. (Only Hedda Hopper seemed to notice. She wrote about it in her column.) Lex Barker (who played Tarzan) lifted me up on his shoulder so I could see what was going on.

We had a few days before the opening of the new studio, so we decided to visit Acapulco. One afternoon Celeste

and I went out with surfboards. I wouldn't exactly call it "surfing"; we paddled beyond the breaking waves and just floated. At one point I yelled to Celeste across the water.

"Look how big the waves are getting."

"I see them," she yelled back. "And they all have fins."

Shark alert! A whole school of them, as it turned out.

Celeste and I were both very light and very fair. Those sharks must have seen us and thought, "Hey guys, look—lunch."

That's when Celeste and I learned to be speedboats, using our arms to paddle like hell toward the shore. The lifeguards were already on their way to save us. We didn't realize how far out we'd gone. Talk about your dumb tourists.

Celeste and I escaped being lunch in Acapulco, and ever since then I've avoided swimming in the ocean.

There were all kinds of fun things to do on this Mexico trip. I danced with Gary Cooper at a party. Gary was already in town to shoot *Blowing Wild* with Barbara Stanwyck. He was one of the handsomest men I'd ever met, and I've met quite a few lookers.

Miguel Alemán Valdés Jr., the son of the outgoing president of Mexico, took us all to a villa outside the city so Daddy and Jeanette could attend the bullfights. I wasn't interested in watching bulls die, so Miguel's associate Enrique Parra Hernández offered to show me around. Enrique had been President Valdés's right-hand man on

economic matters. He was just ending his job as the director of Mexico's National Bank of Foreign Commerce.

"Let me show you the apartment I keep for my mistress," he offered.

It sounded interesting.

Once we were there, he said, "Let me show you the bedroom."

I didn't think much about it. I knew Enrique was married and had a family. Besides, he had a mistress. He was busy enough.

Over the bed was a huge oil painting of a beautiful red-haired movie star I knew: Maureen O'Hara. Wow. I didn't know Maureen had a lover in Mexico. Unlike Hedda, I didn't keep track of everybody's affairs. I was still the Virgin Mary Frances from Burbank, and I was shocked.

But that was just the first course. While I was staring at Maureen's portrait, Enrique gently nudged me onto the bed. In one hand he offered me a ruby-and-diamond bracelet. The other hand was already up my full skirt and pawing at my panties.

Daddy and Jeanette had gone to the bullfights and I got left with the bull.

My years as a gymnast paid off—in one swift move I got away from him. Then I demanded we return to Miguel's villa.

Luckily Enrique took no for an answer. Daddy was another story. When I told him what had happened, he hurried Jeanette and me onto a plane back to LA.

A few months later, Miguelito (our nickname for Miguel) came to visit me in Los Angeles. He was very handsome, tall and dark-haired with impeccable manners. Looking back at pictures of him now, I realize that Miguelito resembled Eddie Fisher. I guess dark, handsome men were becoming my "type."

On our first date, he gave me a gold pin and a beautiful heart-shaped pearl-and-diamond ring. Daddy hit the roof when I showed them to him. He told me I couldn't accept such personal and extravagant gifts. I was very upset.

With my friends Olympic champion Bob Mathias and actress Celeste Holm on the beach in Acapulco.

Miguelito was a gentleman. He hadn't made any plays like his friend Enrique.

Miguelito came to the house to speak with Daddy. He explained that the jewelry was a gesture of friendship, nothing more. He must have charmed Daddy, too, because I got to keep the gifts.

Can you believe it? A few years later I lost the ring when I washed my hands in a ladies' room at the Horn Comedy Club in Santa Monica while I was out dancing. But to this day, I still have the pin.

EDDIE CANTOR THROWS AN ENGAGEMENT PARTY

Eddie Cantor was a very popular entertainer from the early 1920s until his death in October 1964. He started in vaudeville and also made many radio and film appearances. He was known for his songs "Makin' Whoopee" and "If You Knew Susie." Like many comics of his day, he worked in the Catskills, which was known as the Borscht Belt.

That was where he discovered Eddie Fisher, at the popular resort Grossinger's, in 1949. Cantor gave Eddie a lot of support and was his mentor when Eddie was starting his career. And he didn't want Eddie to marry me. Cantor

felt that Eddie's career would suffer if he did. He wanted Eddie to continue to be a young heartthrob. Eddie's manager, Milton Blackstone, felt the same way. They also thought that Eddie wasn't ready to settle down. I thought so, too. When we met, he was dating at least two other girls and made a date with Pier Angeli for the same night he invited me to see him perform at the Cocoanut Grove. But I accepted Eddie's proposal. I was in love with him, and believed he was in love with me.

Cantor finally accepted that Eddie and I were getting married, and as a gesture of goodwill threw a big engagement party for us at the Beverly Hills Hotel. He invited four hundred people—the A-list of Hollywood at the time.

The party was held on Saturday, October 30, 1954, in the hotel's Crystal Room. The Cantors did a beautiful job. There were huge bouquets of flowers on a raised platform behind a long table spread with a magnificent buffet. Eddie's parents made a special trip from Philadelphia to attend. Edward G. Robinson brought his wife, as did Jack Benny and Fred Astaire. Other married couples who came were Gordon MacRae and the actress Sheila Stephens, Ann Blyth and Dr. James McNulty, and George Burns and Gracie Allen. Even the mayor of Los Angeles and his wife put in an appearance. Joan Crawford came stag. Photographers circulated through the crowded room, taking pictures.

Three of my good friends who'd also gotten engaged

recently came with their fiancés: Vera Ellen with Vic Rothschild, Pier Angeli with Vic Damone, and Jane Powell with Pat Nerney. Designer Helen Rose had thrown a bridal shower for us a week or so earlier.

For my engagement party Helen made me a powder-blue gown to wear, because blue was Eddie's favorite color. Eddie gave me a bracelet with two strands of pearls; the clasp was a round diamond. (Comedian Henny Youngman joked that I was breaking my engagement because I'd found out that the diamond was really a piece of broken Coca-Cola bottle. Coke was the sponsor of Eddie's TV show, *Coke Time*.)

Later that month Eddie took me to visit his parents in Philadelphia. One of the local papers ran a picture of us sampling his mother's cooking. Dorothy Kilgallen wrote in her syndicated "Voice of Broadway" newspaper column about Eddie and me attending the Metropolitan Opera in New York, being photographed by reporters, and going to a club afterward. The only sour note was a three-part syndicated article running in many papers about how Eddie might not be ready for marriage (sometimes in the same issue with local ads for my movies *Athena* and *Susan Slept Here*, which was then a big hit).

We were married on September 17, 1955, at Jennie Grossinger's home in Pennsylvania. Our friend Mike Todd gave us a reception after we got back from our wedding, at the Bel Air home of Nicholas Schenck (pronounced "Skenk"). Mr. Schenck was one of the big bosses at MGM.

Louis B. Mayer hated him, and privately called him "Mr. Skunk." Sonny and Cher later purchased his house.

That party was more sedate. Studio executives Jack Warner, Lew Wasserman, and Samuel Goldwyn were there, along with Gary Cooper, Lucille Ball and Desi Arnaz, and a lot of wealthy society folks.

That was a happy time in my life—fun and exciting. I remember it well to this day. Eddie Cantor and I became friends, and he introduced me to many comics who also became my friends.

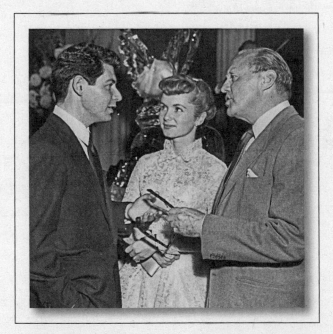

With my fiancé, Eddie Fisher, at our engagement party at the Beverly Hills Hotel. Eddie Cantor threw this celebration and invited everyone in Hollywood, including the darling Jack Benny.

OVER THE RAINBOW TO LONG BEACH

After my dear friend Judy Garland was fired from MGM in 1950, she concentrated on doing concerts, including her historic four-week run at London's Palladium and record-breaking nineteen weeks at the Palace Theatre in New York. She divorced Vincente Minnelli in 1951 and in June 1952 married her tour manager and arranger, Sid Luft. Five months later she gave birth to their first child, and Judy's second daughter, Lorna.

In March 1954, Warner Brothers hired Judy to do a remake of *A Star Is Born*, directed by George Cukor. The film opened at the end of September to rave reviews and great box office, and Judy was later nominated for the Academy Award as Best Actress. She was in the hospital the night of the Oscars ceremony, having just given birth to her son, Joey, on March 29, 1955. A television crew had been sent to broadcast her anticipated acceptance speech.

Sadly, Judy didn't win. Many were shocked when Grace Kelly won for her role in *The Country Girl*. As wonderful as Grace is in that film, I felt Judy should have won. The story goes that Groucho Marx sent Judy a telegram saying that her loss of the award was "the greatest robbery since Brinks."

In spite of its popularity with moviegoers and critics, *A Star Is Born* lost money due to problems Judy had experienced that resulted in production overruns. So once

again, in 1955 she was unemployable as an actress and in the position of having to make a comeback.

Sid was Judy's manager and business partner by then, and they decided that she would do another concert tour. It was a big production involving fifty-five people, with an all-male chorus of dancers; special material written by Roger Edens, Leonard Gershe, and Kay Thompson; and directed and choreographed by Charles Walters. Chuck had started out as a choreographer on films such as *Best Foot Forward*, Judy's *Meet Me in St. Louis*, and *Girl Crazy* (in which he'd partnered with Judy on-screen). He'd gone on to direct many hit musicals, including *Easter Parade* starring Judy and Fred Astaire, and, much later, my own *The Unsinkable Molly Brown*. He also directed Frank Sinatra and me in *The Tender Trap*, a cute film that was a lot more fun to make than it is to watch. (I recently saw it on Turner Classic Movies.)

Judy's tour was scheduled to begin in San Diego on July 8, 1955, and to move on from there to the Pacific Northwest, British Columbia, and (with the great trumpet player and bandleader Harry James joining) across the US. A dress rehearsal was held at Pasadena Civic Auditorium on July 6, to which several columnists were invited.

Judy didn't want to appear anywhere near Los Angeles or Hollywood. But then a Long Beach theater-chain operator asked her to consider doing a benefit for their

Exceptional Children's Foundation, and Judy agreed. (*Exceptional* was the term used then for "special needs.") They added a performance, to be held at Long Beach Municipal Auditorium on July 11. More than a hundred local organizations sponsored ticket sales, and notices appeared in the papers.

Of course all Judy's friends wanted to go. I was working with Frank on *The Tender Trap* then, and engaged to Eddie Fisher. So when Frank told me he was chartering a bus and invited Eddie and me to join him on it, you couldn't have kept us away. I asked Frank if I could also bring along my friend Margie Duncan and Bernie Rich, who was Eddie's best friend from Philly. Frank was happy to have them. That bus contained a Who's Who of Hollywood: David Niven, Dean Martin and Jerry Lewis, Lana Turner, Humphrey Bogart and Lauren Bacall, Betty Grable and Harry James, Edgar Bergen, Donald O'Connor, Art Linkletter, Sammy Davis Jr., Dick Powell and June Allyson, Jimmy Stewart, Ronald Reagan, Gary Cooper. Peter Lawford and his wife, Pat, were there. So was makeup man Keester Sweeney. (I just love his name.) The papers reported that nearly a hundred seats had been sold to celebrities, including Jack Warner and Jack Benny, who would be driving the twenty-five miles down to Long Beach.

Our bus ride was a show before the show. Everyone was in a festive mood. Dinner and drinks were served. Frank told Bogie to sit next to the bus driver and give him directions,

I guess because Bogie had played Captain Queeg in *The Caine Mutiny*. Betty Bacall sat a few rows behind Bogie. At one point she yelled out, "Hey, somebody's feeling me up back here."

"Let me know if they find anything," Bogie responded, without missing a beat. "I've been looking for years."

The bus was like summer stock on wheels. Everyone was laughing, singing, joking around, and having a wonderful time.

The Municipal Auditorium was built on twenty acres of landfill that extend five hundred feet into the Pacific Ocean. It has since been replaced by the Long Beach Convention and Entertainment Center. An alley between Ocean Boulevard and Seaside Way had been roped off for the stars' vehicles. This led to a platform outside the auditorium for visiting stars to be interviewed as they arrived. Klieg lights flooded the sky with wandering rays of light, and movie and television cameras were everywhere. Our bus was scheduled to pull up alongside the platform at around 8:00 P.M., and to wait for us just outside the entrance to the auditorium for the return trip.

The advance publicity had done its job, and hordes of people assembled behind the roped-off areas and the mall. As our bus pulled up, about a thousand people mobbed us. It was crazier than a Hollywood opening.

Finally we were in our seats, eager for the show to begin.

Judy entered from behind her dancers. It was so brilliant. The house went crazy. She sang eleven songs,

starting with "The Man That Got Away" from *A Star Is Born* and including all her standards—"Rock-a-bye Your Baby," "After You've Gone," "Zing! Went the Strings of My Heart," and others. She did two dance routines, one with Paul Sanchez, "We're a Couple of Swells" (the "tramps" bit she first did with Fred Astaire in *Easter Parade*), and a comic dance routine with the Wiere Brothers. I had worked with the Wiere Brothers when Carleton Carpenter and I were on the vaudeville circuit several years before promoting our hit song "Aba Daba Honeymoon" from the movie *Two Weeks with Love*. It was wonderful to see them again. In between, Frank Fontaine did his stand-up and the Hi-Lo's male quartet performed a few of their hits, including their cover of "Whatever Lola Wants" from *Damn Yankees*.

Judy was magnificent throughout. She ended with "Over the Rainbow," and the audience gave her a standing ovation that lasted several minutes, calling loudly for "More!" She obliged them with four encores, including "Swanee" and "Liza." Then, while the crowd continued to cheer, she asked, "Would you like to meet some of my friends?"

More cheers as she invited Frank to the stage. Frank got Bogie and Betty up there. Dean and Jerry, Eddie and I, Betty Hutton, Dick Powell, June Allyson, and Sammy Davis Jr. joined them. Dean and Sammy performed a Martin and Lewis song, with Sammy imitating Jerry. Finally Bogie told everybody to get off the stage, and the unofficial show after the show ended.

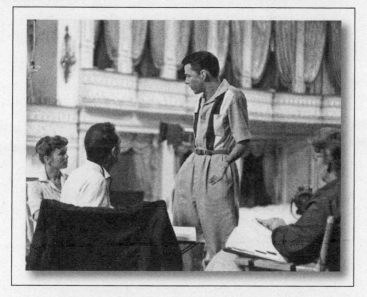

*Frank Sinatra and Chuck Walters working with me
on the set of* The Tender Trap *in 1955. Frank invited us all to take
a bus to Long Beach to see Judy Garland in concert.*

Frank had the concert recorded and later gave copies to his friends who'd attended.

As it turned out, that show was the end of Judy's comeback tour. Sid and Judy canceled it when CBS signed Judy to do her first TV special that September, which was so successful that CBS signed Judy to do one special a year for three more years.

I hope Judy had as much fun as we did that night.

Frank always threw a great party. I don't remember who his date was that evening, just that she was a beautiful blonde. While he was married to his first wife, Nancy, Frank

was always with other women, in Hollywood and in every other city he visited. Yet Nancy is the loveliest lady there is. When Frank fell for Ava Gardner, he wanted to marry her; but he always took good care of Nancy and the children. There was no one like Frank.

Or Judy!

..

..

"DEBBIE MAKES A SPLASH!"

That was how they reported it.

In 1960 I was asked to perform at a benefit for the Hollywood Boys Clubs and the Big Brothers of Greater Los Angeles, sponsored by the local radio station KLAC. It was their eleventh annual *All Star Charity Show*, to be held at the Hollywood Bowl. That year the other stars included Bob Hope, Rosemary Clooney, Steve Allen, Jo Stafford, Mickey Rooney, Janet Leigh, Jimmy Durante, Zsa Zsa Gabor, the Mills Brothers, and Gisele MacKenzie, among others. There were two popular musical ensembles: Paul Weston and His Orchestra and Teddy Buckner's Dixieland Band. The emcees were celebrities in their own right, disc jockeys from the station known as the "Big Five": Dick Haynes, George Church III, Ross McCoy, Bill Stewart, and Ray Belem.

The event took place on June 25, a Saturday. Everyone was in formal wear. Even the deejays wore white dinner

jackets with their black slacks. My gown was an exquisite handmade Helen Rose creation that had a full skirt of white organdy with a white chiffon net overlay embroidered with flowers that took many seamstresses a week to sew.

I had worn this dress at the 1958 Academy Awards to sing "Tammy" when the song was nominated. The song and the dress were favorites of mine. They still are.

I was the last person to perform that night. My first album, *Debbie*, had been released recently, and I did a few songs from it, including my hit single "A Very Special Love" from 1958. I ended with my big hit, "Tammy," which I've always sung as the final number in my act. I was thrilled by the crowd's enthusiastic response, and thanked them.

At that time, between the amphitheater seats and the stage in the Hollywood Bowl's iconic big white shell, there was a reflecting pool. As I was thanking the audience I got an idea.

"Now we'll really get into the swim of things," I announced, and said to the deejays, "It's time to go into the pool!"

Then I ran across the platform that separated the stage from the edge of the reflecting pool . . . and jumped in!

And the deejays jumped in after me—white dinner jackets and all—as though it had all been planned.

The place went into an uproar as eighteen thousand people sprang to their feet, cheering and laughing.

The show was a smash. We raised a lot of money for the kids. Everyone had a great time.

Sometimes my comic escapades cost me some very beautiful dresses.
This Helen Rose gown was exquisite—until I jumped into the pool.

Looking back on it now, I don't know why I decided to jump in the pool, but I went right into the water without thinking about those big lights under the surface. I felt a sense of euphoria, and that seemed to be the best way to top off the evening. I didn't even think about it; I just jumped. It was probably the dumbest thing I ever did. It's a miracle we weren't all electrocuted. It was the biggest splash of the time and got a lot of press, but it was taking a huge chance. In those days, I was game for anything. I took everything as a challenge. I loved being that carefree. I'd do anything for a laugh, even if it meant getting all wet.

I'm glad that I did it—except for the dress. I was de-flowered as soon as I hit the water. My gorgeous gown was ruined in an instant. I loved that dress. It made me feel beautiful while I wore it. I've always felt bad about ruining it.

A couple of years later I received an invitation I couldn't refuse.

MAKING A GOOD IMPRESSION

The Chinese Theatre on Hollywood Boulevard near Highland Avenue in Los Angeles is a very popular tourist destination. In the late 1920s the owner, Sid Grauman, had the idea to have movie stars put their handprints, footprints, and signatures in the sidewalk outside his theater. He started with Mary Pickford and Douglas Fairbanks, and ever since then almost two hundred stars have left their mark in the Grauman's walkway. So I was very excited to be invited to have my hands and feet immortalized this way, especially since it was in the desirable area in front of the theater doors. Outside of New Jersey, there aren't a lot of occasions when people ask you to put your feet in cement. And at the Chinese Theatre it's a *good* thing.

I planned my outfit very carefully. You have to bend

over to put your hands in the cement, and I didn't want anything falling out of my dress. I wanted to be elegant and appropriate for this special day. I was about to plunk my little size fours down next to the prints of great stars like Lillian Gish and Joan Crawford.

Bill Travilla, who designed Marilyn Monroe's famous pleated dress for *The Seven Year Itch*, made me a sapphire-blue dress with a square neckline and short sleeves. I wore a fabulous blue pillbox hat. Most importantly, I chose a pair of shoes with high heels so my feet would look small in the pavement—just the pointed soles of the shoes, an empty space, and two round dots for the spike heels.

The ceremony took place on January 14, 1965, a beautiful, sunny day. When I was getting ready to go to Grauman's, I felt sick. But nothing was going to keep me from this event. I would have gotten up off my deathbed to be there. Put together from hat to heels, I got in the car for the drive to Hollywood.

Once I arrived, the fans made me feel better. A lot of people showed up. They cheered as I leaned over to place the palms of my hands in the wet cement. After I wiped off my hands, I leaned on the gentleman to my right, who kept me steady while I put first one foot, then the other, on the slab. One of my fans shouted out that I should give him a shoe for a souvenir, but I needed them and had to say no. Finally I signed my name and the date, and everyone went across the street to the Roosevelt Hotel, where there was a party.

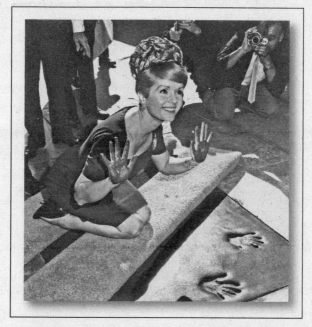

*Making a good impression at Grauman's Chinese Theatre.
I was thrilled to be invited to join the many stars who had put
their handprints and footprints in the courtyard.*

In a lifetime that has had a great share of special mo-
ments, this one still makes me very proud—and people who
visit now wearing sneakers aren't able to fit their feet in my
footprints.

It turned out that leaving my mark in cement for pos-
terity was just a beginning. Three months later, on the
morning of March 23, 1965, I had my own close encounter
with the Final Frontier.

MOLLY BROWN IN SPACE

In 1957 the Russian satellite Sputnik became the first spacecraft to orbit the earth, launching the race to the moon between the US and the Soviet Union. John Glenn was the first American to successfully orbit the earth. Alan Shepard and Gus Grissom were among our first astronauts to fly outside our planet's atmosphere.

I met Mr. Grissom on a visit to NASA headquarters in Houston. He kindly let me sit inside the space capsule. It was an amazing experience to actually see how the astronauts travel. Such small quarters.

Gus Grissom was in a Mercury space capsule called the Liberty Bell 7 that sank when it landed in the ocean on his return trip. For his next trip, in 1965, he nicknamed the Gemini 3 spacecraft *Molly Brown*, after my movie, in hopes that it would be unsinkable.

When I heard about this, I was like a kid at Christmas. It was such an honor. I sent him a gift with a note that read:

All the world will be watching, especially your gal Molly Brown. Wanted to send you my red lace long drawers (worn in the film) but the worry warts say no. So here is my prettiest lace scarf for luck. Happy landing, Molly Brown.

My scarf arrived a few hours before Gemini 3 was scheduled to lift off from Cape Canaveral. Even though it

wasn't allowed, Gus Grissom took the scarf on board, and he and fellow astronaut John Young also wore patches with their names and "Molly Brown" on their uniforms. Much of America watched the launch on TV.

The *Molly Brown* orbited the earth three times. It was a relief when they landed safely. What a thrill for me to be a small part of our country's space program!

THE SONG-AND-DANCE TROOP

In 1965 Carrie was attending El Rodeo Elementary School. The Boy Scouts Clubhouse was right next to the school. The mothers were invited to come to a meeting about creating a Girl Scout troop. I had always loved being a Girl Scout. I used to sell Girl Scout cookies on the Warner Brothers lot when I was a teenager, long before I was employed there. Even Hedda Hopper bought cookies from me. I was thrilled to have the chance to pass on the Girl Scout experience to my daughter. I was making *The Singing Nun* at that time. I left the set during my lunch break to attend the meeting.

I arrived just as it was starting, and sat down next to one of the other mothers. A woman teacher who looked about forty gave a pitch for ten minutes then asked if there were any questions. The woman beside me raised her hand. She

asked where the troop meetings would take place. Could we have them at our homes? She mentioned that she'd led both Girl Scout and Boy Scout troops back in New Jersey, where she'd come from. She said she also threw in a little arts and crafts and music.

"You could do it anyplace and any way you want to," the teacher answered. Then she said, "Who of you would like to take a troop?"

I shoved my elbow into the ribs of the woman beside me.

"You seem like a nice broad," I said. "Let's take a troop together."

The woman agreed.

I raised my hand.

"We're not taking nuns," the teacher said, seeing what I was wearing. I didn't have a lot of time for lunch, so I'd driven to the meeting in my habit from the film.

"I'm not a nun in real life," I said. "My daughter goes to school here."

I told my new partner that I was on my lunch hour and had to leave, and asked if I could stop by her house for a drink after I finished work at five.

"Absolutely. Come by."

Her name turned out to be Sandy Avchen. A professional musician and vocal coach, before moving to Los Angeles she'd worked with Florence Henderson, who was doing a Broadway show. Sandy had been raised near Hoboken, where Frank Sinatra grew up. Her family were lawyers for

Frank's family; they bought their Cadillacs from the same people. She was already doing shows with stars like Charlton Heston to raise money for the schools.

When I got there, Sandy was waiting for me with her four kids. We talked until around 9:00 P.M., we were so excited about creating our own Girl Scout troop.

We wound up with twenty-four kids, including my daughter, Carrie. There was another troop of twenty-four, and they all wanted to be in our troop. But we couldn't handle any more girls. My producer on The Singing Nun kindly gave me Wednesday afternoons off to be with them. Sometimes my shooting schedule didn't leave me time to change out of costume and I'd show up in my nun's habit as I'd done at the meeting at Carrie's school. The kids loved it, but some of the mothers thought I was a nut.

We were the talk of the town, known as the song-and-dance troop. We had a lot of celebrity kids. Sid Caesar's daughter was with us, and Sid's wife was always hanging around. There were a few mothers who were extremely helpful.

Once Sandy and I wanted to take the troop camping and hiking in the desert to earn merit badges. At that time I knew the president of Western Airlines. So I called him and said, "Listen, I want to fly my Girl Scouts to Vegas," and he kindly arranged a flight for me and Sandy and our troop. Another time everyone came to my house in Palm Springs. I knew the owner of a big bus company, and he provided us

with one of his buses and a driver. The kids all slept on my floor, and earned badges for horseback riding.

Sandy and I used to do shows. We'd rehearse down at El Rodeo.

For our first or second Halloween together, we decided to take the girls trick-or-treating on North Roxbury Drive in Beverly Hills. A lot of stars called this neighborhood home, and many of my friends lived there. After putting Carrie and Todd to sleep I would often leave them with the nanny, drive around making visits, and wind up on Roxbury. Lucille Ball's house was on the corner of Roxbury and Lexington, above Sunset Boulevard. Jack Benny lived next door to her. Jimmy Stewart, Rosemary Clooney, and Agnes Moorehead (one of my costars in *The Singing Nun*) all lived on Roxbury, as did Eddie Cantor. They all knew one another. When they had parties, we all were invited. Agnes gave a big Christmas party every year, and everyone came. It was a very fun place.

That Halloween Sandy and I both dressed as clowns. The girls dressed in whatever costumes they wanted. We piled into a station wagon and a van and were on our way.

We went to Lucille Ball's house first. Sandy and I led the girls up the long front lawn and rang Lucy's bell. Lucy herself opened the door. Her husband, Gary Morton, was standing behind her.

"Oh, who could this be?" Lucy asked sweetly.

I leaned in and said, "It's me, it's Debbie."

"And who are these adorable kids?"

"My Girl Scouts."

"Show me your costumes."

She was very cute about it all. Gary was a bit grumpy, but Lucy was really sweet when faced with a crowd of excited little goblins.

She invited us into her living room. The girls surrounded Lucy as she handed candy to each of them.

"Don't forget to go next door," she said.

Lucy waved good-bye as we started for Jack Benny's house. The girls were all laughing and thanking her.

At Jack's house we repeated the routine.

"Well, who have we got here?" Jack asked, holding his right elbow with his left hand, the palm of his right hand to his face—his famous pose.

I whispered in his ear, "It's Debbie, and this is Sandy."

He turned to a table next to the door, picked up a basket, and gestured for the girls to step forward, saying, "I have a basket full of money here."

The girls lined up—and he gave everybody dimes! A single dime apiece out of his money basket.

The troop continued up the street to Jimmy Stewart's home, then across Roxbury to Agnes Moorehead's. Everyone was so nice as two dozen kids showed up on their doorsteps.

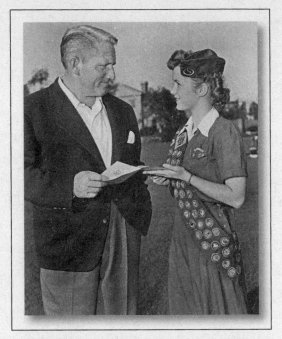

Spencer Tracy was such a wonderful star. I'm sure he was thrilled to be buying cookies from MGM's newest contract player. He won an Academy Award, but I had forty-seven merit badges.

To this day, I continue to support the Girl Scouts. When I performed in the 1970s, they paid half price to attend my concerts. I don't sell cookies anymore, but I'm happy to lend my name to the organization. Even though I thoroughly enjoyed my years as a troop leader, Carrie tells me now that she hated it. We have very different tastes.

I miss those days when I would visit my friends' homes on Roxbury Drive. Sandy and I are still close to this day.

FISH SHTICK

In June 1971 Sea World opened their new attraction in San Diego with a killer whale named Shamu. The huge black-and-white orca supposedly weighed forty-seven hundred pounds and ate more than two hundred pounds of fish a day; one extra visit to the sushi bar and she would have tipped five thousand. She was enormous.

And so was the playground the park had created for her—a 625,000-gallon performing tank measuring 120 feet long, 50 feet wide, and 24 feet deep, on seven additional acres of land Sea World had acquired just for this attraction. It held a million gallons of water. More than one hundred fifty trees had been planted, and another two and a quarter acres of lush green lawn with decorative ground cover bordered the water. It looked like a lagoon.

As if that weren't enough, there was a wall of twenty-three wide Plexiglas panels on the audience side of the show tank, for underwater viewing of Shamu's antics.

The opening event was a show called *Shamu Goes Hollywood*, with proceeds to benefit the Motion Picture Relief Fund. The owners of Sea World asked me to sponsor it, and I was happy to do so. Robert Wagner and Natalie Wood, Glenn Ford, Shirley Jones, Ricardo Montalban, Jean Simmons, and Jack Haley Jr. agreed to help publicize the festivities.

At one point, I was standing at the edge of the giant pool watching Shamu's flips and jumps with her handlers when the killer whale sped toward me. Shamu rose out of the water with her jaws gaping wide. The handlers led me over to her, and asked me to put my head inside her mouth.

I'd been nervous before at openings but this one *really* scared me. I leaned forward until my wig was in her nose, praying that Shamu wouldn't mistake me for a fish stick. One sniffle and I would have been Jonah of San Diego.

Shamu didn't chomp me. But on the drive home from Sea World I still couldn't shake the fresh orca smell. I had noticed that many of the restaurants at the park had a seafood theme. Was this the final fate of the fish who misbehaved?

The following April I read in the papers that Shamu had bitten the legs and hips of a female employee in a bikini, who was trying to ride her during the filming of a publicity promo. When the orca refused to release the woman, they had to pry Shamu's jaws apart with a pole.

Shamu was a magnificent creature, but they retired her from performing after that. She's lucky she didn't end up as the Catch of the Day in one of their eateries. I counted myself lucky, too. I had survived my own close encounter with her jaws.

BERTHA THE ELEPHANT

When you played concert dates in Las Vegas in the 1970s, it was usually part of the deal to also appear in Reno. Just east of Reno is Sparks, Nevada, which also has casino hotels, so many of us played there, too, at the Nugget.

One of the greatest performers to ever grace the Nugget stage was Bertha the Elephant, who was the hotel's main attraction from 1962 until she died in the late 1990s. She had her own act in the Circus Room with her baby, Tina, and she would briefly share the stage with me or Liberace or Tony Bennett—whoever was the headliner that week. Bertha was truly a Nevada favorite; she and Tina also appeared every year in Carson City at their Nevada Day parade.

She had her own elevator in the backstage area. I played that club for years before they let me go on that elevator with her. Bertha's handlers would take her outside to do her business. She let loose on command when they tapped her on the leg. She was better trained than some performers I know of.

But once in a while she would make a mistake, and when that happened you really thought Niagara Falls had moved to Sparks, Nevada. The whole audience would be underwater. We'd run out with mops to mop up, and then I had to go on with my act. My beautiful costumes all turned a little yellow from elephant pee.

When we humans played the Nugget, we had to work seven nights a week, with an extra ten minutes on Monday night. Somebody once asked the entertainment office why we had to do a longer show on Mondays.

"That's Bertha's day off," we were told.

Mondays off while everyone else made up for her act? That pachyderm had a better contract than we did!

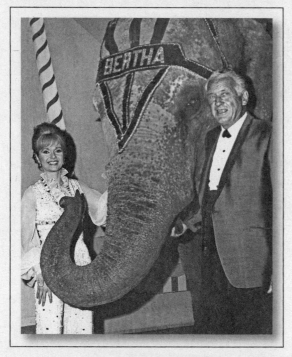

Bertha was the most cherished entertainer in Sparks, Nevada. She even had her own elevator to get to the stage. Here I am with Bertha and a friend of hers.

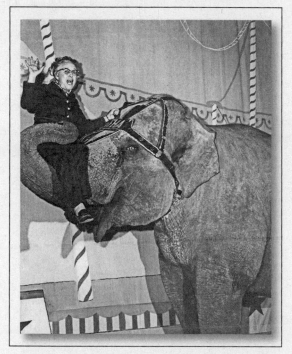

Superstar Bertha giving my mother, Maxene, a lift.

4

·······

It's the Pictures That Got Smaller

*I*n the early 1950s, Louis B. Mayer, the head of MGM, called television "a passing fancy." Although Mr. Mayer knew movies, he wasn't right about the new wave of entertainment called TV. When I was asked to appear on Ed Sullivan's first program, *Talk of the Town*, Mr. Mayer forbade me to do it. The studio did allow me to go on the show in 1953 to promote their new film *I Love Melvin*, which I made on location in New York City with Donald O'Connor.

When Eddie Fisher had his weekly TV series, I was a guest on his show. As television grew in popularity, the movie business had to adjust. Nowadays all the film studios produce TV shows as well as feature films. RCA and NBC pioneer David Sarnoff and his wife, Lizette, were very kind to Eddie and me. We had dinner at their home while on our honeymoon trip. Mrs. Sarnoff gave me a powder-blue evening bag covered in pearls. (I recently gave it to my granddaughter, Billie.)

Being on talk shows has always been fun. In the days when there were only three channels to watch, these shows had good audiences. It was also an opportunity for the networks to add more commercials to their schedule, since in the early days many stations went off the air after their late-night newscasts.

Today's talk shows are much livelier than they were then. I've been a guest on most of them. *The View* and *The Talk* are favorites of mine. The conversation is quick and fun when you're surrounded by smart people. I especially loved Dinah Shore's shows. She was a lovely host who made it comfortable for her guests. Oprah, Joan Rivers, Roseanne Barr, and Rosie O'Donnell did, too. David Letterman invited me to be on his show a few times. Jimmy Fallon is such a great talent today. He's really taken *The Tonight Show* into a wonderful, comedic place. What a joy it is to see people doing silly, fun things together. I'm excited about Stephen Colbert's new show. He's always been a favorite of mine.

Craig Ferguson was a real kick in the pants. He really went with the moment, which is so important in comedy. No matter what I said, he was right there with me. I loved doing his show. The last time I was on with him, promoting my book *Unsinkable*, we laughed and cut up. At one point, I giggled and did a little snort at the same time. Craig busted me for it, which got a big laugh. He has the heart of a vaudevillian, too.

One of the secrets of being a good guest is always being prepared for each show, especially when you're on a junket where you're doing ten shows in three weeks. You have to work with the producers to make sure that what you say in your guest spot on *The View* is different from what you say with the morning-show people or on *Access Hollywood*. Joan Rivers was always keenly aware of this, making sure she had different material for each show. Steve Martin, Will Ferrell, and Kevin Spacey are great guests, too—always different, even on back-to-back nights.

I love slapstick, physical humor, and being spontaneous. And, as I've said before, I'll do anything to get a laugh. Sometimes talk shows offered the perfect opportunity to do this.

DEBBIE GOES WILD

When the TV world was still somewhat new, I did a guest spot on Jack Paar's *Tonight Show*. This was in September 1959, shortly after my highly publicized divorce from Eddie Fisher. Before the show, Jack's producers agreed that we wouldn't be talking about "The Scandal." They did ask me to be funny, "not serious." Even in the worst of times, when I'm onstage, I'm never serious.

On the night of the show, I was seated next to Jack at the desk. During our conversation, I admired his tie, which

had a lot of bright colors—like pink and orange. Jack took it off and handed it to me.

"It doesn't match your handkerchief," I said.

He handed me his handkerchief.

Emphatically, I pushed it back into Jack's pocket.

Jack took a pause, looked at the audience with a grin, then turned to me.

"Were you that rough on Eddie Fisher?" he cracked.

I'm sure I blushed, but instead of answering him, I dove under the desk. I reached up and grabbed Jack by his jacket, pulled him to the floor, undid the jacket, and threw it over the desk, followed closely by his wastebasket. I tossed my shoes in the air. A sock or two flew over the desk. The audience screamed at our mock striptease.

When we came up from beneath the desk, Jack's shirt was open to the waist. I was now holding his jacket. He pulled himself back together while the audience continued howling with laughter. At the end of the segment, he helped me put on my shoe. I didn't feel like Cinderella, despite his gallant move.

The press had a field day. "Debbie Goes Wild!" and "Debbie Dishevels Paar in Undressing of the TV Age," headlines blared.

I think Jack was just glad I didn't toss his toupee when we were under the desk.

Years later a reporter asked me about it.

"I didn't plan it," I told him. "I just thought I ought to do

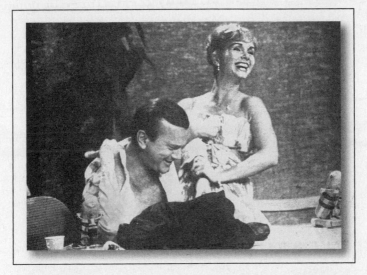

After promising not to discuss "The Scandal," Jack Paar brought up my ex. I dove under the desk, yanked him down with me, and proceeded to go for the laughs. Here we're composing ourselves after our tussle.

something amusing as nothing much was happening on the show. The whole thing was spontaneous. At heart, I guess I'm just a baggy-pants comedienne."

ROLLING WITH REGIS

Joey Bishop was a member of the Rat Pack, along with Frank Sinatra, Sammy Davis Jr., Dean Martin, and Peter Lawford. He made his living as a standup comedian and actor, and had his own TV series from 1961 to 1965 in which he played

a talk-show host. Two years after it was canceled he actually had his own talk show. Regis Philbin was his sidekick.

I was one of Joey's guests on the first episode, which aired on April 16, 1967. At one point Joey asked me about being a Girl Scout.

I'm very proud of my time with the scouts. I told Joey that I was currently teaching my daughter's troop the correct procedure to follow if someone's clothes caught fire. Joey asked me what that was. Regis offered to help me demonstrate.

I jumped out of my chair, flew across the stage, and pounced on him, tackling Regis to the floor. He didn't know what hit him.

Regis was a cute young thing in those days, small and wiry and fit. It took me a minute to get him pinned. Then I rolled him back and forth, to put out the imaginary fire, just like I taught my Girl Scouts to do. I was wearing a pale green beaded dress that cost several thousand dollars. It wasn't worth five cents at the end of the show. Regis wasn't very cooperative, and I split the skirt up the front when I straddled him. But that only made it funnier. The audience screamed, as did Joey's other guests.

I scraped my knees doing that stunt, and even bled a little. Bruised and bloodied, I finally let Regis get up. He looked shocked. We both looked like we might have been on fire.

I think Regis appreciated the joke, even if I did muss him up. My performance made the front page of many

newspapers in the country that weekend. The New York *Sunday News* ran a cover picture of me on top of Regis with my hands around his neck, under the headline "The Reynolds Blitz." Inside the paper was a three-page article entitled "Debbie Lowers the Boom." The writer quoted Regis as saying, "I'm honored to be the first man molested by Debbie Reynolds on national television." Although he

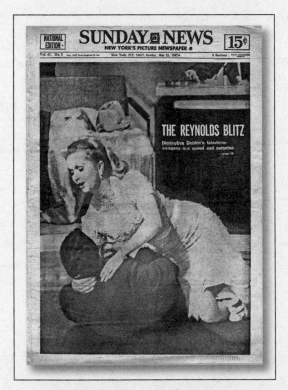

When I tackled Regis Philbin on
The Joey Bishop Show, *our tumble made front-page news.*
Another gown sacrificed for comedy.

also said that he came out of our "tussle" with a scraped elbow, assorted bruises, and "a strange black and blue mark on my thigh," he admitted that if he had really been on fire, I would have put it out in no time.

In a widely syndicated article, the *New York Times* reported that I had "forever shattered" the accepted image of Girl Scouts as young girls in green uniforms "daintily peddling cookies" and replaced it with one of "embryo Amazons." The writer went on:

> *Disregarding a lovely coiffure and striking evening gown, Miss Reynolds executed a diving lunge mixed with the applicable nuances of post-graduate karate. Philbin was instantly prone on the studio floor with the actress simulating the process of smothering the remaining flames with her matching jacket as she rolled the victim over.*

Joey was thrilled—as he should have been. His producers couldn't have bought such great publicity. Joey was very gracious afterward. He sent me a new dress to replace the one I'd ruined on the show.

...

I didn't always have to "molest" my host to be funny, of course. If I did it would become predictable, and I might not have been invited back. But sometimes I wore out a host in other ways.

JITTERBUGGING WITH JOHNNY

In April 1974, shortly after I'd finished my Broadway run in *Irene*, I made an appearance on *The Tonight Show starring Johnny Carson*. I always enjoyed working with Johnny. He was quick with his conversation yet always deferential to his guests, which made him an excellent host.

On this show, I entered wearing a print Gucci blouse with tan slacks. As Doc Severinsen played me on with some lively music, I broke into a few impromptu dance steps. Johnny stepped off his platform and came to greet me. Next thing I knew, we were dancing a jitterbug.

It all happened very quickly. Then we went to Johnny's desk on the platform and talked for a few minutes about disco dancing and the jitterbug. Johnny spoke knowingly about the studio system. We shared our respect for the "old school" way of dancing. I told him that Gene Kelly had taught me discipline.

During the commercial break, Johnny and I went back to the performing area of the set to dance. We were in the middle of some crazy combinations when the break ended. Knowing we were on the air again, we just went with it. Johnny was very good at leading, but when he threw me over his back, it didn't quite work. I slipped off his side and he put his arms under mine, to lift me up. Facing the audience, I started doing Martha Raye's "rubber legs" shtick, crossing one leg over the other while sliding down

closer to the floor. (Martha was a great physical comedian known for slapstick.) My legs were flying every which way. Johnny's lucky I didn't kick him anywhere vital.

Finally Johnny just let me drop to the stage and sat down beside me. We embraced and stood up. Doc switched to some slow music, and Johnny and I started a waltz. What a good sport.

We took our seats and Johnny made a few jokes. "This is cardiac city," he said, and took a drink out of the mug on his desk. He kept talking but was panting, making it difficult for him to speak. He wiped his head with a towel.

I hadn't broken a sweat.

I took over, asking the audience to give Johnny another hand for such a great dance. The audience cheered while Johnny was still catching his breath.

"Why aren't you breathing hard?" he managed to ask me.

"Because I'm in great shape," I replied honestly. I was just coming off a run on Broadway, where I'd sung and danced eight shows a week. Dancing with Johnny hadn't even made me tired.

"Well, I'm going to die," he said, grabbing his chest.

As Johnny continued to drink and joke about being winded, I asked him if he'd like me to help him out. He nodded—and I proceeded to interview myself.

"So, Debbie, let me ask you a question. How is it being back in Los Angeles with all the smog—I mean fresh air—after so long in New York?"

"Well, I'm happy to be back home, but these gas rations have me all mixed up. I'm an odd day but I can't get even."

For you youngsters out there, in the early 1970s our gasoline was rationed. If your license plate ended with an even number, you could buy gas only on even-numbered days. It worked the same way with odd numbers. Gas was only about thirty-five cents a gallon. It went to fifty cents. We were shocked when it reached a dollar a gallon.

Johnny and I compared our ages. I was sure I was older than he.

"Nobody's older than Tammy," I quipped.

We put our heads together, whispering how old we were. I was only forty-two at the time. Forty-two! I've got shoes older than that now.

Johnny asked for an oxygen mask to revive himself. I suggested that we go to commercial. Following the cue cards, Ed McMahon and I told the audience about a rug called Herculon. What a name.

Johnny asked me about being nervous on opening night. I explained that it's only natural to be nervous—you have a lot of new material and want everything to be right. We talked about my being on Broadway. I had done his show several times to promote *Irene*. He'd even had some of the cast on when *Tonight* was in New York for a visit.

We talked about how difficult it is to do so many shows a week. When I went to New York, I found out that the regular Broadway actors are a bit snobbish about motion

picture people. They're used to working so hard, doing eight shows a week. It *is* exhausting, but I was determined not to miss any shows. I wanted to prove that us Hollywood types could work hard, too.

I appeared many times with Johnny and with many of his guest hosts. Once I was on with Jay Leno. Jay used to be my opening act when I performed in Reno and Lake Tahoe, Nevada. He recalled how I had suggested that he get his chin "done." I didn't remember saying that to him, but he actually went to a doctor to see what it would take to make his jaw and chin a normal size. The doctor told him it could be done but it would be a year before he could talk again. That was the end of that idea!

..

I didn't limit my roughhousing to talk shows, and getting older didn't slow me down. Twenty-three years after I wore Johnny out, I got down in the dirt on one of the biggest sitcoms.

..

THE DOMESTIC GODDESS

You have to love a woman who was smart enough to turn jokes about her working-class family life into a sitcom that ran for nine years (from 1988 to 1997) on ABC. One of my favorite lines of hers is, "As a housewife, I feel that if the

kids are still alive when my husband gets home from work then, hey, I've done my job."

Roseanne asked me to be on the third-to-last episode of the show's final season, a real honor for me. I play her character's mother-in-law, Audrey, who has just got out of an institution after being locked up there for nine years by her own son, Dan Connor (John Goodman's character). I spend the entire show trying to kill him for sending me away.

There's a scene in which Roseanne and I get into a fight. When we talked about how we would do it, I assured her that I would be all right. I always did stunts myself—like getting thrown into mud puddles or riding seven-hundred-pound hogs around a barnyard, as I did in the 1959 movie *The Mating Game*. The hog tossed me off his back, then came over and licked my face. Ten years after that I'd done a television special called *The Sound of Children* that featured a big brown bear. At one point, I was told to give the bear a hug. I don't recommend hugging bears. I'll never forget that feeling of getting squeezed in its crushing arms. The bear literally took my breath away. I was scared and amazed that I came out without a scratch. A lot of time had passed since then, but I figured that, even so, I could manage a roll on the set with Roseanne.

The scene takes place in the Connor family's backyard. Roseanne catches me digging a hole to bury my son—her husband—alive. Roseanne and I really go full-tilt world-class wrestling. She throws me to the ground, takes a leap, and

lands on me while I'm lying on my back. Then we tussle and argue, yelling at each other between tugs and punches.

"He'll just put me back in that hospital," I scream.

"Why would he do that? You're well now," Roseanne yells as she rolls over me. "Audrey, what happened to you out there in California? Did you have one too many of those frozen mocha Frappuccinos?"

Finally she drags me off by one leg.

A year later Roseanne had her own afternoon talk show and I was a guest. During our conversation she brought up my appearance on her sitcom. I explained to her that when I got home after filming that scene, my left side hurt me. I visited the doctor, who told me that my rib was broken.

"I call it my Roseanne Rib."

"Oh my God, you never told me that," Roseanne said. "You mean you broke your rib?"

"No. You broke it."

She was so concerned that I had never mentioned my rib. But there was nothing to do about it. Roseanne also seemed surprised that I didn't sue her. There wasn't much point to that.

After all her apologies, she told me that she had spoken with Carrie, who'd shared a story about me.

"Carrie told me that you came out of the kitchen carrying a blender, saying, 'Dear, what is this used for?'"

I was shocked to hear that I had been in a kitchen—not

the room where you'll find me in any house. Roseanne is the domestic goddess, not me. Let someone else figure out what to do with all that machinery.

...

I wasn't always on the giving end when it came to "assault and battery." In 1981 the great TV producer Aaron Spelling offered me my own television series.

...

ALOHA PARADISE

Aaron was the producer of The Love Boat, which ran from 1977 to 1987 and on which I had appeared twice as a guest star. He also created the series Dynasty, which was another huge hit for ABC in the 1980s. Aaron had a really good track record, and I went in hoping for the best. My show was to be filmed on location in Hawaii. It was called Aloha Paradise, and meant to be comedic.

Trust me, it wasn't.

I played the manager of a resort called Paradise Village where guests come to deal with their love lives—either looking for love or falling in or out of it. The two-hour pilot was shot in Kona, Hawaii, a beautiful setting. Everything about it was lovely except the script. The writing was terrible. The producers were very hard on me. They hired someone

On the set of Aloha Paradise *with the handsome Van Johnson.*

to listen to every take to make sure I didn't improvise one word off the script. The lighthearted writing and fun of *The Love Boat* series didn't make the trip to Hawaii.

After the pilot we came back to the States to finish the series at Universal Studios. We had six more episodes to shoot, complete with my script overseer. I hated every minute of it. The only good thing for me was having a lot of my friends come to appear on the show. Jonathan Winters, Van Johnson, Jim Nabors, and many other actors I admire were guest stars, but I was really unhappy.

No matter how bad things get now, I just look on the bright side—at least I'm not working on *Aloha Paradise*!

That covers talk shows and sitcoms. I'll end this chapter with my experiences with another television tradition: the Oscars.

..

AND THE WINNER IS . . .

The 2015 Academy Awards ceremony was dazzling, as usual. Neil Patrick Harris worked extremely hard as the host. Just the opening number was enough, but he made it through the rest of the show wonderfully. Being on all the time must have been so difficult. I could see that he was working to be the best in this big job.

When I costarred with Neil in a TV movie called *A Christmas Wish* in 1998, he was a nice, talented young man. He wasn't familiar with my work, so he rented all my movies. As a young actress in 1948, I never dreamed of a time when you would be able to rent me for two dollars a day. Neil would come to the set having just run *Singin' in the Rain*, and ask me to sing the songs with him. He's my favorite grandson.

I have a long history with the Academy Awards, having been a presenter or performer many times. My first appearance was in 1951, when I announced the cinematography awards in an eleven-dollar dress from Lerner's department store. The first Oscars presentations to be televised were in 1953. Over the years, the show evolved from no-frills black-and-white with no production

numbers into the fabulous full-color extravaganza it is today. And I went from wearing off-the-rack dresses to gowns made especially for me by famous designers like Helen Rose, Bob Mackie, Ret Turner, Nolan Miller, and Ray Aghayan.

In 1978 the Academy celebrated its fiftieth year. For this big anniversary, they announced on March 21 that Gene Kelly would be featured in a "spectacular opening production number" called "Look How Far We've Come." That sounded great. Buz Kohan, one of Carol Burnett's writers, created the special material.

A few days later, Gene was out and Debbie was in. I was asked to substitute for Gene, who was unable to perform. On March 31 the Academy sent out another press release touting "the greatest cast ever assembled for 50th Awards Show." This one mentioned that I would be performing in the opening number. The show was on April 3, and I was on the spot.

Pat Birch was the choreographer. She had worked with Gene and two dozen dancers for this huge five-minute song-and-dance number that took place up and down two flights of stairs spread across the length of the stage at the Dorothy Chandler Pavilion. The routine was built around Gene, featuring lyrics and dances from the Chaplin era right up to *Saturday Night Fever*.

The dancers were dressed in white tuxedo outfits, the men in long slacks, while the ladies wore white shorts and formal jackets with tails. They were all wonderful, young,

and energetic. My costume was brown satin slacks and a tuxedo jacket with sequined accents. I think Bob Mackie helped me with the outfit, but he may have left it to the show's costume designer, Moss Mabry. In addition to the dancing, I had to run up the stairs to a platform for more tap dancing. There were props—bowler hats for Chaplin, top hats for the Astaire lyrics, umbrellas for the *Singin' in the Rain* section that featured Gene's choreography from his famous number in our film.

Rehearsing was grueling. These numbers usually take weeks of planning, staging, and rehearsal. I was dropped into this epic only a few days before an important live performance. I remember driving from the valley over to the dingy Marathon studio on the Paramount lot, where Pat worked me hard to get me up to speed. She pushed me to perform better than I thought I could under the circumstances.

Before long I was tapping, twirling, doing the tango while running up and down the stairs, and grabbing and handing off lots of props. Hats and umbrellas went flying as Miss Burbank moved on to the next dance combination.

At the end of the number on the night of the show, I spoke about all the many wonderful actors who had received an Academy Award, people who are dedicated to excellence. Then former winners in all categories appeared at different levels of the set with escorts in tuxedos who moved them into position on the stairs and stage—everyone

from actors Mickey Rooney, Anne Baxter, and Ernie Borgnine; director George Cukor; costume designer Edith Head; and composers Marvin Hamlisch, John Williams, and Henry Mancini; and many more. Then producer Howard Koch Jr. came out to introduce Bette Davis and Gregory Peck, who talked for another four minutes while the dancers, Oscar winners, and I stood on the stage. Finally, after what seemed like an eternity in stage time, Bob Hope was introduced as the host of the show—his last performance at the Oscars—and as the cameras focused in on Bob we all left the darkened stage behind him.

Like a visit to the White House, going to the Oscars is special. One year my friends from Virginia wanted to go. They paid for the tickets, so I went along. That was in 1985, when Prince was nominated for his song "When Doves Cry" from his film *Purple Rain*. He and two lady friends were seated next to us, which was exciting for the folks from Roanoke. Prince wore a purple lace shawl that covered his head, revealing little more than his eyes. When his name was announced, he took to the stage with the two women on his arms.

"This is Lisa and this is Wendy," he introduced them, then asked Wendy, "Want to hold it?" and handed her his Oscar.

It was a fun moment. You don't get to see things like this on a normal day outside of Hollywood.

In 1997 I was asked to present the Oscar for Best Score. As it happened, my daughter, Carrie, was writing

for the show for the first time. That was the year my film *Mother* was up for consideration.

"Before we get to the nominees," I started, "I'm not going to lie to you. I was a little disappointed by not being nominated myself, but what I did was, I took to my bed for two weeks. And then I discovered this wonderful support group called the Non-Nominees Anonymous . . . or Non-Anon. Well, maybe not so anonymous—Courtney Love, Madonna, Barbra Streisand."

The camera cut to Barbra sitting in the audience next to James Brolin, her handsome husband.

"These wonderfully generous, gifted, *uncomplicated* women . . ."

I paused while the audience laughed, and the camera cut again to Barbra, who lowered her head and raised her hand to her cheek.

". . . these lovely women took me in and nominated me as their friend. So it is to them that I would like to express my gratitude for helping me out of my deep funk into this shallow one. Now to the teleprompter."

I began reading the prepared remarks about the "precious gift of laughter, the audience film comedy provides . . ."

This time the audience's cheers and clapping made me pause, which was perfect for what came next.

". . . the . . . the . . . provides."

I stopped, squinting my eyes and making a sour face.

"Who wrote this *drivel*?" I said. "I would like to meet the writers who wrote this drivel. Is there a writer on premise? Is there a writer in the house? I would like to find out—"

Cut to my daughter entering from the wings, stage right, raising her arms in pretend annoyance, asking, "What? What is it, Mama?"

"Carrie, I can't say this drivel."

"Well, it's my first year writing drivel. I was just following Hal's lead." She turned to the wings. "Could somebody get Hal Cantor? Or Buz, or Bruce?"

No response.

"Well, honey, we'll just cut it," I said.

"Oh, good," Carrie said. "This show could be shorter, anyway."

"Well, *you* couldn't," I cracked as she left the stage.

Carrie's not the only wiseacre in the family.

5

A Picture Is Worth a Thousand *Woids*

As comics, we all owe a great deal to the ones who went before us. Mae West, Moms Mabley, and Fanny Brice broke into the world of comedy where no women had ever worked before. Phyllis Diller was one of the first women to be a successful stand-up comedienne. Phyllis was followed by Joan Rivers, who inspired another generation of female comedy performers. (Phyllis was one of my mentors, as well as my great friend.) For every great comic like Robin Williams, there was a Jonathan Winters who inspired him. Wayland Flowers borrowed heavily from Redd Foxx, with Redd's blessing. Bette Midler's comedy was influenced by Belle Barth and Sophie Tucker. Eddie Murphy inspired Chris Rock. The list goes on.

When I began my film career, I was fortunate to become friends with some of the greatest comedians of all time. This picture is from when the Friars Club honored Lucy on her birthday.

We all love Lucy. This was an event honoring Lucille Ball.
What great company—the best in the business. Milton Berle,
George Burns, Jack Benny, Bob Hope, and Groucho Marx.

I was asked to be the emcee, which I was happy to do.
The tribute was a benefit for a Southern California chil-
dren's charity. The Friars were a rowdy bunch. On this
night, Lucy was roasted by the greats of comedy, who were
also our friends—Milton Berle, George Burns, Jack Benny,
Bob Hope, and Groucho Marx. It was a very special event.

EVERYBODY LOVES LUCY

Was there ever a more talented comedienne than Lucille
Ball? What an inspiration she is to everyone in comedy.
I Love Lucy, her series with her Cuban bandleader husband,

Desi Arnaz, was the biggest hit on television in the mid-1950s. The show was performed live before a studio audience, and used three cameras, a technique that changed the way sitcoms were shot. When it was syndicated, there was always an episode playing somewhere in the world at any given time. The show is still popular today. Lucy's dazzling timing continues to inspire new generations of talented young comics. Her physical ability—the ways she used her body to get laughs—remains unequaled to this day.

In addition to being a great performer, Lucy was also one of the first women to excel in the television business. She produced and owned her shows, which she sold to CBS along with her image and name for millions of dollars at a time when that was really a lot of money. Lucy ran Desilu Studios, which in addition to her own shows produced series such as *Mission: Impossible* and *Star Trek* that continued in one form or another for decades. She was smart as well as beautiful and talented.

Lucy was also a lovely person. Unlike some other comics, she wasn't "on" all the time. She didn't try to be funny when you were around her. But as a comic actress, she was brilliant. Lucy used to visit our house when the children were young. Carrie was mesmerized by her deep voice.

"You're a cute, fat little baby," Lucy would say to Carrie. Carrie loved it.

With people's voices, I was always careful with my children when they were growing up. Babies imitate the

voices they hear. When people use high-pitched "baby talk," the little ones soak it up like sponges. I wanted my daughter to have a well-placed voice, not a high, screechy one like I learned in Texas when I was growing up.

On her *I Love Lucy* series, Lucy did everything. Talk about shtick. One of the most famous is the episode "Lucy Does a TV Commercial." The product is Vitameatavegamin. Lucy "spoons her way to health," getting roaring drunk in the process. You can see it on YouTube. There's nothing funnier—unless you look at Lucy and Ethel working in the candy factory ("Job Switching") or Lucy stomping grapes at a winery in Italy ("Lucy's Italian Movie"). What a treasure.

Lucy loved her husband Desi Arnaz like nobody's business. She was devoted to him. He loved Lucy but he couldn't resist the temptations of ladies and liquor. Desi played around. He was always out somewhere. He was a charmer when he was sober, but when he drank it was all over.

Desi would stay out all night. Sometimes Lucy would call me at two or three in the morning looking for him.

"Why would he be here? You know I would never be with Desi," I reassured her.

"I know, Debbie. But he said that he likes you. I took a chance."

Even after she divorced him, Lucy still loved Desi. I knew that he still loved her, but she had to end it. She was so lonely.

Then in 1960 she met Gary Morton. He was a New York comic who was funny and nice. I had met Gary when I was first dating Eddie. When he was around Lucy, he made her laugh. He didn't have any money when he married her in 1961 but he died rich. He was a good husband. He didn't play around. He filled her life.

When I would visit Agnes Moorehead on Roxbury Drive, we'd go across the street to Lucy's house to run movies and just be girlfriends having some laughs together. I'd always purposely leave something behind.

"Can't you remember anything?" Lucy would say when I came to pick it up. "These earrings are real!"

I wonder if she knew it was just an excuse to visit her again.

I Love Lucy ran from 1951 to 1957. After that Lucy had three more hit series: *The Lucy-Desi Comedy Hour* (1954–1957); *The Lucy Show* (1962–1968); and *Here's Lucy* (1968–1974). Her last show, *Life with Lucy*, ran for only thirteen episodes, in 1986. It broke Lucy's heart when it was canceled. She felt ignored by the public. That really hurt her. She retired to playing backgammon and cards with Gary.

But she loved Desi to the end. When he was dying in 1986, she would go to him, still loving him. They had a special love story.

..

MILTON BERLE

"Mr. Television" and "Uncle Miltie" were Milton Berle's popular nicknames in the 1950s. When his *Texaco Star Theater* was aired on Tuesday nights, business dropped in restaurants and bars because everyone stayed home to watch the show. His program is credited for selling televisions all over America. Milton transitioned from a life in vaudeville to being the first really huge TV star. He was followed by other actors and vaudevillians who became TV stars, like Jack Benny, husband-and-wife team George Burns and Gracie Allen, and Lucy, the queen of the small screen.

Milton was one of the founders of the Friars Club. Whenever he was there he would have himself paged all over so everyone would know he was in the club.

"Milton Berle is wanted in the game room."

"Mr. Berle has a phone call at the front desk."

The Friars was also one of the places my second husband went to gamble every day. Harry played cards with Milton often, and they became friendly. So I also got to know Milton better, and the more I got to know Milton, the less I liked him. His behavior was rude. He used very trashy language around everyone. He loved vulgar humor. (To "clean up his act," he once introduced Lucille Ball as "Lucille Testicle.")

Once Milton was at a party at our house on Greenway Drive. I had new white carpeting everywhere. Not the most

practical choice for someone with children and poodles, but I liked the look of it. Most of my guests were considerate. I did everything I could to make them feel comfortable. Milton was seated in a chair in the living room with his ever-present cigar. He dropped the ashes all over the floor, instead of in a nearby ashtray. When it looked like he was about to drop the lit cigar butt on my rug, I motioned to my security guard, Zinc, to help Uncle Miltie to the car. Milton's wife never came to parties with him, so he left with Zinc.

Of course, Milton's own parties were another matter. At one of them I attended, he'd hired Scotty Bowers to shock the guests, who included great stars like Fred Astaire and Gene Kelly. Everyone was there. In 2012 Bowers published a bestselling memoir about his days as a hustler and sex procurer in Hollywood. He was known for his large endowment. Milton used to have him lay it on a silver tray with parsley and other garnishes, like an hors d'oeuvre, and circulate among the guests. People would try to pick it up from the tray and keep going and going until they realized they weren't holding an actual sausage, then yank their empty hands away. Bowers would say, "Ooh." Not my idea of funny.

But it does remind me of a very old joke that I will share with you. Old jokes get to live on from generation to generation because they're funny. Jokes that die when they're delivered don't get handed down from one comic to the next.

As the story goes, there was a man named Herschel the Magnificent whose "gift" was even greater than Scotty's. Herschel would enter a showroom dressed in his bathrobe. In front of him would be a table with walnuts laid out on it.

Herschel would open his robe, revealing his mighty manhood. Grabbing his penis as if it were a baseball bat, he would walk by the table, cracking each walnut as he passed.

The crowd would cheer at Herschel's special talent. Many people in his audience returned several times to see the show.

Years passed. One day a man who hadn't seen Herschel in a long time decided to catch his act again. Inside the nightclub, he was surprised to see the table laid out with coconuts instead of walnuts.

Herschel entered, older but still virile, and went down the row of coconuts, cracking each one.

After the show, the man went back to speak with Herschel.

"Herschel. It's good to see you're still performing. I've been a fan for many years. But I must ask, why are you cracking coconuts now instead of walnuts?"

"Well," said Herschel, "my eyes ain't what they used to be."

I don't know if Milton ever used that joke. It probably wasn't dirty enough. His fellow comics used to say that it was impossible to steal from Milton because none of his material was his.

One of the last times I saw Milton was at another Friars Club event. Jack Carter was onstage doing his routine. Milton was heckling him from the wings. When that didn't work, Milton started to go onstage to interrupt Jack in person. I grabbed Milton by his shirt and pulled him back into the wings.

We got into a fight.

"What are you, his agent?" Milton yelled at me.

"No, you're just being rude. Stop it."

"Why don't you shut up!"

That was all I needed to hear. I took a swing at him, calling him a son of a bitch. Not very ladylike of me, but at least Jack got to finish his set without any more interruptions.

I really don't like disparaging people, so I'll end by just saying that while I respected Milton's talent, I didn't enjoy being around him.

GEORGE BURNS AND GRACIE ALLEN

When I think of George Burns, I think of a roué. He loved to flirt. If you were sitting next to him, he would always have his hand on your leg, massaging it.

George and Gracie started out in vaudeville with Gracie as the "straight man" but switched roles because she got

all the laughs. George was great friends with Jack Benny. Like Jack, Milton Berle, and Bob Hope, George and Gracie successfully made the transition from the stage to radio, then to film and TV. From 1950 to 1958 they had a television series on CBS called *The George Burns and Gracie Allen Show.*

I went to YouTube to refresh my memory so I could give you an idea of how remarkable they were. Their TV show was really ahead of its time. George would step outside the action and comment to the audience about the wacky goings-on and Gracie's attempts to trick him into doing what she wanted. He'd find out by turning on his own TV set in another room, and watch Gracie scheming with another cast member.

Take the episode "The Termites." Gracie has decided she wants to redo the bedroom and has hired an expensive decorator. Her neighbor and best friend, Blanche, asks if George will care about the cost. "He never cares how much I spend as long as he doesn't know I'm spending it," Gracie explains. Then the decorator arrives, and the three of them talk about what needs to be done. Blanche explains that Gracie wants the redecoration to be a surprise for her husband. He asks where George is. "In the bedroom," Gracie tells him. That's a problem, the decorator says, because he needs to see how much he can salvage (meaning in the bedroom). Thinking the decorator is talking about George, Gracie says, "He's very well preserved." Blanche tells her the decorator means

the bedroom, and Gracie says that if the bedroom looked as good as George, she wouldn't have it done over.

While the audience's heads are still spinning, George enters and Gracie tries to deflect his interest. He leaves and goes into an upstairs room, turns on his TV, and sees her making plans with the decorator. Then he steps outside onto his dark balcony.

"Look, fellas," he tells the unseen camera crew. "It's all right to have it night for the show but for my monologue I'd like a little more light."

The lights come up and he goes into his monologue, addressing the viewing audience and using pauses, the occasional raised eyebrow, and brilliant writing to get laughs. And cigar puffs. ("When I tell a joke, I pause and puff on my cigar," George once explained. "That way, the audience knows I've told a joke.")

"How about that television set of mine?" he begins. "That set's quite a gimmick. Twenty-seven-inch keyhole. Indoor television sets are quite the thing. They've installed some of them in factories already. Boss just sits in his office, turns on the television screen, sees which workers do the most work, and those are the ones he fires. You see, if you work hard you get tired, and the lines show on your face and you don't photograph well. And who wants to look at a bad picture on the television screen?"

George goes on to talk about one boss who installed a secret TV monitor but got suspicious when his employees

showed up at work wearing Max Factor's Pan-Cake Makeup—product placement as punch line! Not only is he describing closed-circuit TV, which had not yet come into wide use, but by joking about everyday people playing to the cameras as though they were actors, George is practically predicting what we've come to know as reality TV!

Then he discusses how such televisions could have changed history, winding up with George Washington at Valley Forge and stating that it could have saved George Washington's soldiers from getting frostbite there.

"In fact, my ankle still bothers me now," he says, and after telling the crew to make it night again on the set, goes back to rejoin the action.

This is only a taste of the great Burns and Allen humor. There are also hilarious visual jokes. Thank goodness for YouTube. Do watch this episode and try not to fall off your chair laughing.

After their TV series ended, Gracie retired from the act. She died of a heart attack six years later. George never remarried, even though he lived another thirty-two years. He continued working until he was in his nineties, following his philosophy of never turning down a job because you don't know where the next one is coming from.

George's philosophy also included carrying over the same things in television that people liked in vaudeville. He produced shows that featured beautiful girls and animals. In his act, George would sing little snippets of songs like

*Halloween with my daddy, Ray Reynolds, while I was
still living at home at our house on Evergreen in Burbank.
I did our makeup myself! Daddy didn't have his teeth in, so his
smile looks really funny. He had no teeth but a lot of love.*

"How could you believe me when I said I loved you when
you know I've been a liar all my life." Then he would put his
cigar in his mouth and wait for the laugh, conducting the
audience with his cigar movements. Great shtick.

When George was eighty years old, he won an Academy
Award for his role in *The Sunshine Boys*. Later he played
God in three movies, the first of which, *Oh, God!*, was a big

hit. He used to say, "Acting is all about honesty. If you can fake that, you've got it made."

In addition to being a man of great humor, George was generous. When you drive around Cedars-Sinai Medical Center in Los Angeles, you'll see George Burns Drive and Gracie Allen Drive. He was a great man who was lucky to find a great woman with talent that equaled his. Bless him.

JACK BENNY

I met Jack in the 1950s, around the time I met Eddie Cantor and many other comics in that circle. Jack was adorable, polite, cuddly. Everyone loved him. We were good friends. Another graduate of the vaudeville circuit, Jack did radio and was under contract for movies for several years at MGM before making the leap to TV. *The Jack Benny Program* ran from 1950 to 1965. What a wonderful, talented man.

Jack had the best timing in the business. He could make an audience laugh just by taking a long pause. He created a character famous for being cheap. One of my favorite bits involves Jack walking along and humming to himself. A man on the street comes up and asks if Jack has a match.

"A match? Yes. I have one right here."

"Don't make a move," the man says. "This is a stickup."

"What?"

"You heard me."

"A stickup? Mister—put down that gun."

"Shut up. Now c'mon. Your money or your life."

Jack takes a long pause, clearly perplexed. The audience roars. The thief grows impatient.

"Look, bud, I said your money or your life!"

Jack throws up his hands. "I'm *thinking*! I'm *thinking*!"

In addition to being cheap, Jack's comedy character claimed to be thirty-nine years old his whole life, a trick that was copied by the Gabor sisters. He also was famous for playing the violin badly. Jack himself was actually a serious musician who owned a very expensive Stradivarius that he donated to the Los Angeles Philharmonic in his will.

Once he was asked to perform with a symphony orchestra. He wanted to do well, and asked me if he could stay at our house in Palm Springs to practice. I was working on a film, so the house was empty. I called the German couple who lived there and took care of the house to tell them that Jack would be our guest for a few weeks. My housekeepers didn't complain but they had to endure weeks of Jack's violin practice. Jack's hard work paid off. The concert received very good notices, which made Jack very happy.

When I played my first Las Vegas gig at the Riviera Hotel, I went all out on producing a great show. My friend Bob Sidney directed. He had been the choreographer on

my 1954 movie *Susan Slept Here*. Bob had me swinging in big birdcages in that film, in addition to many other athletic dance moves. The opening number for my show lasted seventeen minutes. I did a long medley of current songs with a full orchestra and seven dancers. Then I would do another sixty minutes of singing and dancing with some time for costume changes and impressions.

One night Jack came backstage. Always sweet, he complimented me on the show but said, "Why are you working so hard at the opening? Just tell five jokes."

Very sage advice. Jack also helped me with my comedy timing.

"Don't rush the moment," he advised. "Let the audience catch up with you. Wait for them."

That's what Jack did when he worked with Bob Hope. He just stood still, staring at Bob until he felt the time was right to respond. He also told Bob not to speak too quickly. It was wonderful to watch them work together.

Once I learned from Jack to wait, I was able to develop my own style. Only Don Rickles can do that fast insult style. Johnny Carson and Jimmy Stewart had styles similar to Jack's. Johnny especially had great comedic timing that was made more effective by waiting for the audience.

In May 2001 I was invited by the Film Society of Lincoln Center to participate in their tribute to Jane Fonda at Avery Fisher Hall in New York City. Jane's brother, Peter Fonda,

Grabbing the tail of this little guy was only part of the fun when I was making The Second Time Around. *I always did whatever it took to get a laugh! Thelma Ritter stole more scenes than this calf.*

was also there to honor her, along with Vanessa Redgrave, Lily Tomlin, Sydney Pollack, and Sally Field. When I took the stage, I did a full Jack Benny. I stood on my mark in front of the microphone and slowly took in the entire hall from stage right to stage left, looking longingly at the beautiful chandeliers and breathtaking architecture. Finally I leaned in to the microphone and said, "I married the wrong Fisher."

Another piece of Jack's wisdom was "Don't try to be a comic. Be an entertainer. Don't just tell jokes. Tell stories. Your life is ridiculous and madcap and absolutely crazy. Tell the truth about your life." Jack Benny instilled that in me.

GROUCHO MARX

Groucho Marx was another great vaudevillian who made the transition from working in theaters to film and television. He made more than a dozen movies with his brothers, hilarious films like *A Day at the Races*, *A Night at the Opera*, and *Horse Feathers*. From 1950 to 1961, when TV was new, he hosted a game show called *You Bet Your Life*. Groucho asked the contestants questions about themselves, and often responded with spontaneous jokes about what they said. The contestants were always an unrelated man and woman who usually had something quirky about them. After being introduced by the announcer, Groucho would greet each couple and inform them, "Say the secret *woid* and divide a hundred dollars." (The amount rose to $1,500 in later years.) If a contestant said the secret word, a stuffed duck would drop down on a cord from the ceiling, with the word hanging from its long, rounded bill. The duck itself was an exaggerated version of Groucho, complete with an unruly mop of dark hair, bushy black eyebrows, horn-rim glasses, a big mustache, and a bow tie at the base of its long neck. The only thing it lacked was Groucho's trademark cigar.

One evening he was talking to a woman who revealed that she had seventeen children.

"Why so many children?" he asked her.

"Well, I love my husband," she replied.

Groucho waggled his eyebrows and said, "I love my cigar, but I take it out of my mouth once in a while."

Groucho was a frequent guest at my home for parties or dinner. Under his jacket he would always wear a T-shirt with his own picture on it. One night in 1970 we were both guests on Dick Cavett's interview show. Dick did two segments with me, then Groucho joined us for the third. Dick introduced him as "one of the funniest men alive." Groucho came out, stood in the performing area, and as the applause died down began singing his song from the movie *Animal Crackers*.

> *"Hello, I must be going.*
> *I cannot stay,*
> *I came to say*
> *I must be going.*
> *I'm glad I came*
> *but just the same*
> *I must be going."*

His lady friend, Erin Fleming, came out to join him, and sang the second verse. Groucho sang the third verse, gave Erin a peck on the lips, then followed her as she exited. He stopped as she moved behind the curtain, and came back toward the interview area. Dick met him halfway, and escorted him over to me.

Groucho took me in his arms, dipped me backward, leaned in, and kissed me on my lips.

"From one woman to the other?" Dick said, pretending mild shock but smiling.

"They're all alike to me," Groucho told him.

We sat down and Dick asked Groucho if he knew me.

"I could tell you a tale about Miss Reynolds but your hair would stand on its end," he said.

Dick encouraged Groucho to tell it. Groucho turned to me.

"I've known Miss Debbie Reynolds, I guess . . . I guess seventy-five years."

As the audience laughed loudly, I punched Groucho playfully on his lower lip.

Then Groucho mentioned that he'd visited me once in the hospital when I was ill.

"I'm a very kind elderly gentleman," he said. "I visited her to be nice to her, and because I'd always been fond of her husband. I don't remember which one it was."

This time I socked him on the arm and wagged my finger at him.

The audience laughed through all of this, and continued to do so as Groucho explained to Dick that he'd visited me to check out the rumor that I wasn't all I was cracked up to be. This was in the days before breast implants, when girls enhanced their busts with "falsies" or padded bras. It was so unusual that there was a stripper named Carol Doda in San Francisco who was famous for having her breasts enlarged with silicone injections. Dick asked Groucho what

I'd been wearing, whether it was one of "those silly little nighties they put on you."

"Well, she had something like that."

"That was my own nightgown," I told them.

"It was a nightgown that revealed quite more than even the doctor had seen," Groucho added. "I only went there to confirm the rumor that everything that Debbie had was part of her."

"And you're here to tell the tale."

"No, I didn't get any of that."

The audience howled with laughter. I raised my hands in mock alarm, said, "Oh, my dear!" and slapped Groucho on the arm again.

I felt I had to get things under control.

"I was in the hospital, and he called me up," I said, explaining to Dick and the audience what had happened. "I was very pleased that he did call me. And he said, 'I'd like to come over and visit with you.' I was kind of surprised. I mean, he's a busy man. And he came over to the hospital— we're going back thirteen years or something like that— and in comes Groucho and he has a little interview with me concerning how I like show business or show people, or whatever. I didn't know he was copping a little look up there. I wasn't aware of that. I thought we were just visiting and talking."

I turned to Groucho and said, "After all these years, Groucho."

That night I was wearing a summery pale green Empire-style dress with a full, billowy skirt and short sleeves. Both the sleeves and my décolletage were decorated with large white flowers. Groucho's face was to me the whole time I was delivering my monologue, but his eyes were fixed lower, although the audience might not have been able to see this.

"But I've always defended what you had," he said when I finished. "And I still do."

"Well, Girl Scouts can have those things, too," I pointed out, and said to Dick, "You have to watch out for Groucho. He doesn't really mean what he says."

Dick said to Groucho, "You told me once that you can't insult anybody. Even when you actually try to, they take you as being funny."

"I have not insulted Miss Reynolds," Groucho said, and added, as though he wasn't sure of my name, *"Reynolds?"*

"We'll be the judge of that," Dick said with a smile, and cut to a station break.

It seems that Groucho really was preoccupied with my chest. Sometime after the Cavett show he ran into Carrie in front of the famous Nate 'n Al's Deli in Beverly Hills, and told *her* about how he had visited me and my breasts.

The visit that Groucho was talking about on the Cavett show and outside the deli had happened in 1959, when I was making *Say One for Me* for 20th Century Fox. I'd tripped over a cable on the set, banging up my knee, and developed a blood clot. This could have been fatal if it

dislodged and landed in my heart or brain, so the studio had insisted that I go to the hospital. Groucho had come to the hospital to interview me for a book he was writing about old Hollywood. He knew how much I loved the stars like Mary Pickford and Harold Lloyd. But it seems he was more interested in my breasts. I wonder if it was Groucho who started that rumor in the first place. I never heard anyone else mention it.

Groucho wasn't the only man with my breasts on his mind. At around the same time, I was recording the songs for *Say One for Me* with the Fox orchestra. The conductor, Lionel Newman, was a scamp. He was always teasing the ladies, clowning around with actresses like Marilyn Monroe and Jane Russell. When I showed up one day to work with the musicians, Lionel made a crack about me in front of everyone. He said something like "Nice breasts, Debbie. You really look sexy."

Maybe I should have been flattered, but instead I complained to the head of the studio, Darryl F. Zanuck. Lionel told the guys that Mr. Zanuck told him not to make any more wisecracks about me. When I came in the next morning to do another playback with the orchestra, Lionel was quiet. For about ten seconds. I was sitting on a stool in front of the musicians, waiting to start work.

"I'll tell you, Debbie," Lionel said. "Even though I got chewed out, you still have nice breasts."

All I could do was laugh with him.

During a break with the musicians while recording the music for Say One for Me. *Composer Sammy Cahn, Lionel Newman, and lyricist Jimmy Van Heusen. Why is Lionel smiling?*

In my 1968 movie *How Sweet It Is!*, there's a scene in a kitchen where Jim Garner and I are having a fight. I'm wearing a raincoat. Jim calls me a middle-aged mother. I flash open my coat, revealing my blue bikini, and say, "Is this the body of a middle-aged mother?"

I've never felt self-conscious about my body. But, unlike some of my girlfriends at MGM, I was also never known as a pinup girl. I guess it's flattering to have had Groucho Marx and others admire me that way, because now I live in Beverly Hills and my boobs are in San Diego.

BOB HOPE

Bob Hope was a comedy institution, yet another vaudevil-
lian who made his way through every genre of show busi-
ness. Most famous for his seven *Road* pictures with Bing
Crosby and Dorothy Lamour, he did many specials for NBC
over the years, always ending with his theme song, "Thanks
for the Memory." He hosted the Academy Awards nineteen
times. He loved playing golf, a sport he shared with several
of our presidents that he had as friends.

Bob was also a notorious womanizer. Being married to
his lovely wife, Dolores, for sixty-nine years never stopped
him from having affairs. Once in Las Vegas he introduced
me to his current mistress when Dolores was only a few
feet away. I was shocked.

We did a lot of shows together. On one of his specials,
Jack Benny and I were guests. Of all things, Jack and Bob
played college students. The fact that they were in their
sixties didn't seem to bother them. In another sketch,
I played an Eva Gabor type, covered in ostrich feathers,
jewels, and chiffon. I did the whole bit with my Hungarian
accent that I'd worked up from being friends with Eva.

Dorothy Lamour, Jane Russell, and I were Bob's guests
on another special. (Jane had starred with Bob in his 1948
western comedy movie, *Paleface*.) Dorothy and Jane were
doing a read-through with Bob. I don't know where I was
that day. Dorothy warned Bob that he couldn't give me

a joke with a punch line that ended with the word "fork" because I would surely make something of it that might not play on TV. Bob hated improvisation. Every word he spoke was always scripted. Jane told me later that Bob just cut the joke.

Bob loved a laugh. Our friend Phyllis Diller gave him credit for launching and helping her with her career. They talked on the phone every day to share jokes. Bob had a recording device next to his phone so he could keep all the jokes Phyllis told him. If he didn't like the joke, he would tell her to think of another one. They were thick as thieves about the material. Bob lifted material from other comics. Dean Martin borrowed from Jerry Lewis. Every comic called on Bob for material.

Like George Burns, Bob lived to be a hundred years old. During his long life he did so much for charities all over the world. The other thing he was most famous for was the work he did with the USO entertaining our troops, beginning in 1941 with World War II. He did fifty-seven tours, the last one in 1990 when Bob was eighty-seven. For his ninety-ninth birthday, the military honored him for his many years of service to the troops. I felt privileged to be asked to speak. At the end of my speech, I was thrilled to be able to tell Bob, "Thanks for the memories."

6

......

The Royal Treatment

This is a clip from the May 20, 1959, issue of a Salt Lake City paper, the *Deseret News and Telegram*:

DEBBIE PLAYS CINDERELLA FOR BELGIUM'S BAUDOUIN

HOLLYWOOD (UPI)—Bachelor King Baudouin of Belgium met an array of glamorous movie stars Tuesday but he seemed to have eyes only for Hollywood's newest bachelor girl, Debbie Reynolds.

The 28-year-old ruler twice had the petite beauty as his table partner, and both times he had little conversation with anyone else.

He and Miss Reynolds danced into the early morning hours at a party Thursday night held in his honor. The party didn't break up until nearly 2:00 A.M. about half an hour after Miss Reynolds left.

I had just divorced Eddie Fisher and was busy filming *It Started with a Kiss* with Glenn Ford. The divorce had dragged on for the better part of a year, and I was happy to throw myself into work. Part of my job as an actress involved doing publicity for MGM, which often invited VIPs from all over the world to visit the studio. One of these visitors was King Baudouin of Belgium, who was on a twenty-one-day tour of the United States.

The king came to visit the set, where he was introduced to Glenn Ford and me. He looked at the Lincoln Futura convertible that we were using in the movie, which later became the Batmobile on television.

The studio had a luncheon for the king so he could meet Frank Sinatra, Gina Lollobrigida, and Eva Marie Saint. Glenn Ford and I were seated on either side of Baudouin. Glenn didn't get a chance to say much, as the king and I really hit it off. Baudouin was a handsome young man, tall and good-looking, sweet and lanky. He reminded me of Jimmy Stewart.

That evening, producer Mervyn LeRoy held a party for the king at his ranch-style home in Bel Air. I went to the event unescorted, wearing a long green dress with a white fur wrap. Most of the other guests were married couples—Natalie Wood and Robert Wagner, Dick Powell and June Allyson, Kirk Douglas and Anne Buydens.

Shortly after I arrived, an eight-car motorcade pulled up, bearing the king and his entourage.

The king and I danced the night away. At around one in the morning, I whispered in the king's ear that he should meet me the next day, and left the party.

Protocol required that the king travel with his entourage at all times. Baudouin snuck away to meet me in Culver City and I drove him in my convertible to the beach. We laughed and had a wonderful time together. He was adorable. I was adorable. He wasn't flirty or fresh, just happy to be away from his handlers on a carefree little adventure. And I enjoyed playing hooky from my studio bosses.

Meanwhile, there was mayhem in the royal ranks because the king was missing. When we arrived back at the studio in the late afternoon, a gang of furious royal handlers was waiting for us. They said we weren't allowed to see each other again. After all, he was royalty and I was a commoner. (Maybe they were worried. The king's father had married a commoner as his second wife, and then abdicated the throne to Baudouin, who was only twenty-one at the time.) The studio people were mad at me for causing a riot with the handlers.

But I wasn't done with this king. When Baudouin visited New York City before returning to Belgium, I found out where he was going to be, flew to New York, and crashed a party to see him. I smiled at everyone, shook their hands in the receiving line, and got myself into the ballroom where the party was being held. When King Baudouin saw me in the chiffon dress that Helen Rose

made for me, we both grinned. We knew we were getting away with something. We had another wonderful evening of small talk and dancing.

The king of Belgium and Miss Burbank the commoner got along just fine.

Baudouin wasn't my only royal conquest, so to speak. There were always kings, queens, and princes strolling around the MGM lot to meet movie royalty. King Hussein of Jordan also came to MGM in 1959 while I was making *It Started with a Kiss*. Two of this king's favorite movies were *Singin' in the Rain* and Glenn Ford's *Teahouse of the August*

A royal encounter with King Baudouin of Belgium.
When the king came to visit the MGM studio, we hit it off. Miss
Burbank had an adventure with this lovely man.

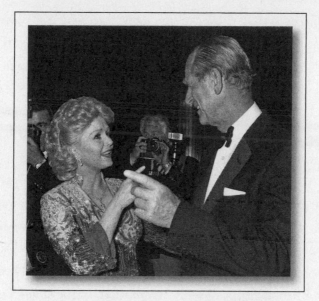

At a special event to honor Bob Hope, we all met
Prince Philip. This prince was charming.

Moon. King Hussein ran copies of our films in his private screening room in Jordan, and he made a point to visit our set while he was in Hollywood.

And King Baudouin wasn't the only member of a royal family I dealt with outside the studio. In 1985 I got groped by Queen Elizabeth's husband in London.

I was there as part of a "homecoming" special to celebrate Bob Hope's eighty-second birthday. (Bob was born in England, in a town called Eltham.) Dozens of stars participated: Sir Michael Caine and Sir Ben Kingsley. Phyllis Diller, Charlton Heston, Bernadette Peters, and Chevy Chase. Many of us were Bob's friends. I took my mother,

Maxene. We flew over on the Concorde, which she loved. Brooke Shields and her mother, Teri, were on the flight.

At the end of the show Prince Philip came onstage to personally honor Bob for his many achievements. We all joined the prince and Bob for the curtain call. The queen wasn't along that evening, which may explain what happened to me.

I chatted with Prince Philip a bit, and had the opportunity to speak with him again at the reception afterward. He was very charming. He put one arm around my waist, then held my hand. Almost immediately, he was holding more than my hand. He caressed my backside. I had heard that he was famous for his "admiration" of the ladies, but I didn't expect him to be handling my booty. As handsome as Prince Philip is, I wasn't sure if he was making a pass or just exercising some royal rights to squeeze the foreigners.

Actually, it was quite an honor to be patted down by this adorable prince. Once Robert Kennedy had made a similar move while we were dancing, but his grope was less charming than the royal one.

Then there was the shah of Iran.

MAGIC CARPET RIDE

In 1976 I met the shah's elder sister, Princess Shams. She was in the United States because her youngest child,

twenty-five-year-old Princess Shahrazad, was getting married to a Texan—in Texas. The wedding was to take place on September 16, the same night I would be opening my show *Debbie* on Broadway for a limited run. Princess Shams saw me horsing around—you know how serious I always am—and she thought I was kind of funny. And, being a princess, of course she had *perfect taste*. She invited me to come to Iran and sing at the palace she shared with the shah. I thought, "Isn't that chic? I've never done anything like that." I figured I was lucky to get through school in Burbank, and now the only way I could get any education was to travel and mingle with the rich.

My daughter, Carrie, and my stepdaughter, Tina Karl, were starting out on their own and had just taken an apartment together. Todd also had his own little place. All my children were gone. (I didn't want any more. They're so hard to get out of your body. I just don't know why the Lord didn't give Eve a zipper. Wouldn't that be easier? "Zip. Hi, Mommy!")

So I went to Tehran. It took me five days to pack, because I knew I wasn't a chic lady. Who had time for all that? Shopping and fittings bored me. I had enough fittings to deal with at work. I traveled only with my hairdresser, Pinky, and a pianist to accompany me when I sang. We had something in common with Shahrazad's husband: we were also from Texas.

We stayed for about a week. Tehran was a very exciting place. It's a big city, with five million people, and looked like

it was war-struck, because they were putting up buildings everywhere and they were all only half done. It appeared as if they'd start on one, finish half, and then go on to another one. The royal family lived in the Pearl Palace, but we were entertained in five or six different residences.

The Pearl Palace came as a big surprise to me. Usually when you think of a palace, you picture something very traditional—a lot of marble and pillars, and tapestries hanging everywhere. At least, I did. This palace was completely modern. It was only six years old then, a complex of circular pink, domed buildings designed on instructions from Princess Shams by Taliesin Associated Architects. That was the firm founded by Frank Lloyd Wright to carry on his architectural vision after his death. The princess had respiratory problems, so she had the designers include streams and ponds, pools and fountains, with running water throughout the palace. There were birds all over the place inside, and the domed ceiling over the main pool was mother-of-pearl. Imagine the singing of birds that flew around the huge crystal chandeliers that sparkled with lights. There was exquisite stained glass in the windows. It was all truly beautiful, and almost fancy enough for my friend Liberace. And a little scary. There were men with machine guns everywhere you looked—on the roof, on the grounds—and armed helicopters constantly flying overhead, like something out of a James Bond movie.

The palace was not located in Tehran proper but in

Mehrshahr. A driver would pick us up at our hotel and take us to the palace; the ride took over an hour. The drivers were always all lit up, their eyes twirling. I don't know what they were on.

On one visit, the princess took us to a room to show us the Crown Jewels of Iran. After the shah was overthrown, in 1979, the jewels were placed in the National Treasury. The Iranian Crown Jewels are the largest and most dazzling jewel collection in the world. They have been described as "a sea of light." The collection is so valuable that it serves as a reserve to back the Iranian national currency.

Another day, the princess screened a movie for us. Princess Shams was famous for having *lots* of dogs, and they had free run wherever the princess was staying. While we were watching the movie, a servant came in, and right behind him came two poodles that sat on a wonderful chaise longue, across from me. Then in came a terrier, and that one went on the chaise longue. Pretty soon the chaise was full of little dogs. Thank god the big ones didn't come in. I had no room on my chaise for any of the princess's bulldogs!

On the day I was to entertain the royal family, everything went well during rehearsal. The piano was in tune and the sound equipment worked. I went into a private room to get dressed in my white beaded Bob Mackie gown. I was very thin then, and I looked fabulous, if I may say so myself. As I was putting on my makeup, I heard Pinky scream.

"I forgot the wig!"

I always wear wigs when I perform. It saves wear and tear on my own hair. Luckily I had thrown two small hairpieces into the makeup case from the day before. After a flurry of back-combing and hair spray, Pinky had me ready to perform.

Pinky is Armenian. The shah thought she was Persian. Before I started singing, he introduced himself to Pinky and took her to meet his wife, leaving me behind. "What am I, chopped liver?" I asked her.

Then the royal family seated themselves in a semicircle in the middle of the room. Protocol required that everyone stand unless the shah told you to sit down. Only he could say who might be seated in his presence.

My accompanist sat down at the piano. I picked up the microphone to sing the Carpenters song "We've Only Just Begun"—a nice romantic tune. It was my understanding that I was just going to do a few numbers. When I finished my set, everyone was very enthusiastic. I left the piano and walked toward the shah.

His Imperial Majesty didn't move.

"Sing another song," he said.

"What would you like to hear?"

"Something by Sinatra."

So I sang one of Frank's songs.

Still the shah remained sitting, looking pleased . . . and *expectant*. So I kept singing—about eight more Sinatra

standards. By now I was wringing wet, because I was the only one in the room moving around.

The shah continued to sit, and nodded for me to continue. So I moved on to Tony Bennett and Ella Fitzgerald, until I was running out of gas as well as material.

Finally I couldn't take any more. As I wound up what I intended to be my last song, I made my way over to the shah . . . and sat on his lap.

Everyone gasped so loudly they probably shifted the air currents in Iran that day.

The shah just chuckled. He didn't seem to mind at all.

I was led away to an open door. I had no idea where I was going, but I was fine with that as long as I didn't have to sing anymore.

It turned out to lead to the place where we would have dinner—an enormous, beautiful room with long tables in the center and tables laden with food along the walls. That was for the three hundred guests, most of whom had to eat standing up. I was seated with the family, near the shah. This was very unusual, and I was thrilled. The other two hundred fifty guests stood eating their meals at the buffet tables. I wouldn't have been able to make it through the meal if I had to stand the whole time.

Princess Shams wasn't the only dog lover in her family. The shah also loved dogs. There were two dogs in the dining room the size of small horses. They must have been

Great Danes. When dinner was served, a beautiful plate with a large steak was put in front of me. Before I could lift my knife and fork, one of the dogs had taken the whole steak and swallowed it in a few bites. Not one to stand on ceremony, I said, "The dog ate my steak."

"Yes, he likes steak," the shah replied matter-of-factly.

He motioned to one of the many servants to bring me another. In a moment, my plate was replaced with another identical one, holding a lovely new steak—which the same dog promptly scooped up.

So much for my steak dinner. There were huge bowls of caviar on the table the size of vegetable dishes. The dogs didn't seem to care for caviar, so I turned my appetite to that. For some reason, at that time I believed that caviar was fish caca, not their eggs. I told myself: "As long as I don't think what that is, I like it." And it was heaven—really good!

I kept looking around, hoping for some rich, single prince to take an interest in me. But I didn't meet any. The Iranian men I met liked their women zaftig. I didn't have quite enough meat on my bones for them. Besides, they all had large mustaches, which didn't appeal to me. I didn't want to kiss that.

The next day, a messenger arrived at the hotel with a gift for me. I'd expected a little something from the shah, maybe a small turquoise or some trinket. Was I surprised when they brought me a rug! A beautiful, handmade Persian

carpet. I still have it in my home. I've enjoyed it every day in the years since then.

When I was performing my *Alive and Fabulous* one-woman show in London in 2010, the shah's younger brother came to see me perform. What a gorgeous man. He reminded me of Tyrone Power. He lives in London now. He has beautiful light skin and dark hair. He's one of the most handsome men I've ever seen.

My trip to Iran was thrilling and interesting and a whole other world I'd never experienced—then or since. I thought all Middle Eastern countries had camels but I couldn't find any. All Iran had was oil, lots of caviar—and large, beautiful dogs.

A ROYAL PARTY

In July 2011 I was invited to attend a party for a Saudi Arabian prince named Azmil who was celebrating his twenty-ninth birthday in London. My assistant Jen went with me for the festivities. We both brought our best party dresses because the events would be formal. We arrived in London on Friday, July 8, and settled in for a rest at the hotel.

The celebration was a three-day affair, and celebrities from many fields would be attending. The first party was held in the ballroom of a castle that was a two-hour drive

from London. Aside from an older group of American movie stars, it was a very young crowd. I danced with many of them as Bruno Mars and his musicians rocked the room on the bandstand.

For some reason the young prince only had eyes for me that night—on the dance floor, that is. We literally danced almost every dance together. It was wonderful. This Prince Charming was adorable.

The Italian actor Roberto Benigni was milling around. After his stunt when he won the Academy Award, I was hoping he wasn't going to be jumping on the backs of our chairs. A very lovely middle-aged Chinese woman was following Roberto around. Maybe he wanted to jump something else.

Jen and I didn't get to bed until 3:00 A.M. We slept all day to prepare for the second event, a formal dinner in London. Jen and I were seated at a large round table with Hilary Swank and (I believe) David Beckham. It was a lovely dinner and we were back in bed by midnight.

Once again we slept late. The combination of jet lag and partying late demanded it.

The final event was another formal dinner party, this one under a big tent that looked like no expense had been spared on the decoration. This time we were seated with Whitney Houston, Faye Dunaway, and my friend Joan Collins. Miss Dunaway was giving off a "Shelley Winters" vibe—that look in her eyes that a Method actress gets when

there is no acting to be done. Whitney looked beautiful. Jen looked lovely in a new, long black gown.

The service was quite slow. Dessert wasn't served until midnight. At 1:00 A.M. Bruno Mars in his white hat got up to entertain. But by then Jen and I had had enough. We snuck out before we turned into pumpkins and went to bed—and were happy to return to our own homes in Los Angeles the next day.

7

······

Friends Without Benefits

What would I do without Turner Classic Movies? For an old movie queen like myself, it's the best place to see all the wonderful films that were so important to me when I was growing up. I run the channel day and night. The other afternoon I was watching the original *Oceans 11* with Frank Sinatra and the rest of his Rat Pack friends. Shirley MacLaine was also in the movie. She was one of the ladies that Frank hung around with in those days.

Shirley MacLaine was a sex goddess. All the boys who kissed her, on-screen and off, said she was the best. Her brother, Warren, also excelled in this department, having dated many of the world's most beautiful women.

A reporter asked me a few years ago if I had any regrets in my life. Aside from the obvious bad choices in husbands, I told him that I wished I had had more sex. I added that my lack of passion probably cost me dearly in my marriages. I know it cost me other opportunities.

When I was married to Eddie Fisher, he used to say, "Let's have sex. You get started and I'll join you later." I had no idea what he was talking about. How could I? I was raised by very strict Christian parents who taught me nothing about sex except to always say no. My mother and Daddy got married when she was only sixteen. She had no idea what marriage was, except that she would have her own dresser for her few items of clothing. Daddy spent days explaining lovemaking to her. He drew pictures so she would know what to expect. My parents were happily married for fifty-seven years. They didn't speak for forty-two of them, but that's all right.

At MGM I was one of the few actresses who lacked for romance. Hedy Lamarr was one of the busiest gals on the lot. And the Brits were a frisky bunch. All the actors and actresses who came over from England spent a lot of time with each other and the natives. Jean Simmons once had an affair with Richard Burton while her husband, Stewart Granger, slept upstairs in their bedroom. The studio legend was that Burton climbed in their basement window to meet Jean. MGM was buzzing about it.

There were so many handsome men and women thrown into one place to work, it's no wonder there was a lot of romance in the air regardless of anyone's marital status. I was never good at this game, so I never really tried to play it.

I was married when I made *How the West Was Won*. One of my costars was the most adorable, handsome, charming

Mother and Daddy on their wedding day.
She was even more naive than I was when I got married.

man you could ever hope to meet. George Peppard played my nephew. George was single and dating many women who were more beautiful and sexual than I. He did not seem to be attracted to me, so we became dear, close friends. My fantasy would be to take a step beyond that friendship. I would love to have had the courage to try just a kiss. I was afraid I'd like it too much, and get caught up with a divine-looking man in a situation that could go nowhere. I was

very insecure at that time and I remain so. I'm not the kind of woman who can step forward to have a wild love affair just to see if it works. I'd love to have known where that kiss might have led. Would it have been to something more? *Could* it have been more? Those are the questions. Do I have answers? No, I do not.

If I had been more adventurous, I might have tried to have a romance with Jack Lemmon. What a darling. I would have liked to just hold his hand. But he married Felicia Farr, whom he loved and adored. Even though he dated quite a few ladies, Felicia was the one he chose for his wife.

Plenty of men had made passes at me but most were married at the time. One day I went over to Buddy and Sherry Hackett's house to pick up Carrie and Todd after school. While our kids played in the next room, Buddy put his hand up my skirt and down my blouse at the same time. I had never had anyone be so rude or as sexually crazy as he was. He thought it was funny. I didn't. I told him off but I should have slugged him. Maybe I didn't because the children were so close by.

Glen Campbell once pinned me to the pool table in his rec room. I had gone to his home to rehearse a number we were doing at a Thalians gala. Next thing I knew, Glen was on top of me. Always the gymnast, I wiggled out from his grasp and was in my car before he knew it. I adore Glen, but not when he was looking for an afternoon delight. Glen is one of the best musicians ever. He did amazing work on his own

as well as with other great musicians. I was so sorry to hear about his Alzheimer's diagnosis. He has faced it so bravely.

Of the many times I've been romantically involved, most are not worth writing home about. But some have been with very nice men—temporarily.

......

ANCHORS AWEIGH

Donna Reed was one of my best friends from MGM. Most famous now for her role as Mary Bailey in *It's a Wonderful Life* opposite Jimmy Stewart, she won an Academy Award for her portrayal of Lorene Burke in *From Here to Eternity*. Donna, Janet Leigh, and I were very close to our teacher and mentor at the studio, Lillian Burns Sidney. The three of us worked hard to help Lillian put her life together after George Sidney left her.

Donna's third husband, Grover Asmus, was a lovely man. They were married for twelve years or so before Donna died in 1986. Grover was a lifer in the military, having graduated from West Point in 1946. He was in the Korean War for several years. Afterward he was stationed all around the world. He became fluent in French while serving in France as an aide to General Charles D. Palmer near Versailles. In the early 1970s he became the senior aide to General Omar Bradley, even doing some consulting on the movie *Patton*.

After Donna died, Grover and I stayed friendly. When I was invited to the Palm Springs Film Festival one year, I asked him to go with me as my escort. We began dating and after a while we became romantically involved for about a year.

My high school friend Paula Kent Meehan invited us to go on a cruise of the Mediterranean with her and her then-husband, John Meehan. Paula was a brilliant businesswoman who cofounded the Redken hair-care company. Bob and Margie Petersen were also on that trip. We sailed all over the south of France along the Côte d'Azur in Paula's yacht, *The Dreamcatcher.*

I preferred to have my own room on board, close to Grover but not too close. Paula insisted that Grover and I occupy the suite on top of the ship, saying she didn't have space for us to be separated. So we were together. Grover stayed up later than I did one evening and returned to our room very drunk. He frightened me. So I ordered him out, telling him he'd have to bunk somewhere else on the ship. He was very upset about that. He went outside and down the stairs to the main deck.

There he decided to jump overboard. I heard the splash and went to wake up Paula. She woke up her husband, who woke up the captain. The captain woke up the crew, who went down to the wharf to yank Grover out of the drink. Luckily, we weren't out on the open seas.

Once Grover was safe, they took him ashore. It was clear that he was going to have to get home on his own.

After all that experience in the war and his military training, I was sure he would manage.

When I got back to LA, Grover came to my little house in the valley to pick up his luggage. He still had a bruise on his forehead where he'd bumped into the wharf. He was very apologetic.

We never dated again but we remained friends. He was the first man to literally fall overboard for me.

..

..

GOLL-EE

Jim Nabors was most famous for his role as Gomer Pyle, first on *The Andy Griffith Show*, the homespun series that took place in Mayberry, then on his own spinoff, *Gomer Pyle, U.S.M.C.*, which ran from 1964 to 1969. Jim's catchphrase for his naive character was a surprised "Golly," which when delivered with his southern accent became "Goll-ee."

Once Jim was established as a television star, he also became famous for his beautiful singing voice. After *Gomer Pyle* he had two other weekly series. I appeared more than once with him and we did some wonderful sketches together. He's just so adorable.

When we performed in Vegas, we would spend a lot of time together. He would be working at the Sands and I'd be at the Riviera, and afterward we would hang out—Jim and I

Jim is one of the dearest friends you could ever have.
We did many shows together, which were always the most fun.

and whoever was working with me. At his hotel, the Sands, they had little private bungalows with a pool. We would sit together soaking and drinking, and talk about our evenings. "How was the audience?" "Did anything funny happen?" It was so much fun. I loved being with Jim.

So one night I said to him, "Look how much fun we have together. Why don't we get married?"

"I can't marry you, Debbie," he said. "I'm extremely fond of you, but I have a man in my life."

I was stunned. It never occurred to me that Jim was gay.

"Well, I can't marry both of you," I said.

"No, but we'll always be the best of friends," he responded.

And so we remained the best of friends.

When Jim worked in Hawaii, he decided to move there. That was where he met the love of his life, Stan Cadwallader, who was a firefighter. Thankfully, the world has changed since then. Jim and Stan were married in 2013 in Seattle after Washington voted to allow same-sex marriages. They've been together for almost forty years.

I'm so happy for them.

Can I get a "goll-ee"?

A GUY CALLED ZIGGY

In the 1980s I went to the wedding of one of my girlfriends' daughters—on my own, because that was how my life was at that moment. I was seated at a table with seven people I didn't know. One of them was a man named Ziggy Steinberg.

You have to love a name like that.

Ziggy and I started talking, being friendly. He told me he's a comedy writer and had worked for great comedians like his buddy David Steinberg (no relation), Lily Tomlin, and George Carlin. He wrote a feature movie for Richard Pryor and Gene Wilder called *Another You*, as well as television

scripts for *The Mary Tyler Moore Show, Three's Company,* and *The Bob Newhart Show.*

I certainly was not looking for a new boyfriend, but sometimes you meet someone who is just plain fun. Ziggy and I hit if off. He is so funny. Even though he is fifteen years younger than I am, he's attractive and his sense of humor made him even more so. We had a short fling.

But my friends were worried.

"Debbie, he's so young," they said. "Aren't you afraid that dating him could be fatal?"

"What the hell," I said. "If he dies, he dies."

8

......

You Got to Have Friends

*B*eing a contract player at a film studio gave me the opportunity to meet so many different, wonderful people. I made it a point to make friends with as many of them as I could. And I continued to do this as my career and my life branched out into other areas. To me, my friends are my family.

..

TERRY AND HER RICH MEN

Terry Moore was one of my girlfriends in the early days. At the time of this story, she'd already starred in the box-office hits *Mighty Joe Young*, in 1949, and in 1952's *Come Back, Little Sheba*, for which she was nominated for the Academy Award for Best Supporting Actress. A few years later she was in *Peyton Place*.

Sometime in 1953 I went with Terry to Las Vegas. We stayed at the Desert Inn. At twenty-four, Terry was recently divorced from her first husband, and one of the most sought-after young women. Terry was a strict Mormon, but somehow seemed to enjoy a freedom that I never quite understood until much later in my life. Nicky Hilton was calling. Howard Hughes was calling. And Bob Neal, the heir to the Maxwell House fortune and Nicky's closest friend, was calling. These were all playboys, very rich men. That phone rang off the wall. I wondered how she kept them straight.

One night all three men were involved. Terry said to Nicky Hilton, "Come to the lobby and I'll meet you there." She also arranged to meet Bob Neal. Then Mr. Hughes called.

"I'll have to see you later," she told him. "There's something I have to do. But Debbie could meet you."

So I met Mr. Hughes, and he taught me how to play craps. He didn't play himself, but he taught me. He just stood beside me at the Desert Inn casino while I played for a couple of hours. He was very conservative: we stuck to one-dollar chips. I didn't win anything, but I did have a wonderful time. Nobody knew who he was because he looked so nondescript in his tan jacket and tennis shoes.

The next night I went out with Bob Neal. I felt I was becoming a Girl About Town. We were driving along the Vegas Strip when Bob warned me he was going to step on the gas because we were being followed.

"What does that mean?" I asked him.

"Howard is having us followed," he said.

"Howard? Do you mean Howard Hughes?"

"Did you say something to him? Did you go out with him?"

"Terry sent me. She couldn't go with him last night because she was seeing you and Nicky. So I went with Howard and we played craps."

"Howard really wants to find out if you're jailbait, or if you're doing anything with me," Bob said. "He likes to know everything."

(Howard Hughes preferred young girls. He liked cute little things with big breasts. Terry was young and beautiful, a year older than me, and had a great bosom. I'm sure she and Mr. Hughes had an affair to remember. At the time of this story, Howard also had about six girls he kept in an apartment, and then never had anything to do with them. He just wanted them off the market, on call. They all looked alike. He had all these girls stashed away, yet they were never close to him. I believe the only women he ever really loved were Katharine Hepburn and his wife, Jean Peters.)

So Bob drove at top speed down the Las Vegas Strip. It was a wide, untraveled road then, not like it is now. All of a sudden he made a U-turn, spinning the car around, and screeched to a halt, facing the car behind us. He jumped out and went to have words with the men in the other car. Bob was right; it was Howard's men, keeping tabs on us.

Mr. Hughes had a lot of people working for him but he was the most solitary man. Quiet. He had no friends. He lived on an entire floor at the Desert Inn. And we all know the story about how they called him and asked him to move out because they needed his suite for a high roller.

"That's ridiculous," he said. "I've lived here for three years. Why would I move?"

So he bought the hotel. He called up the owner and made him an offer he couldn't refuse. That was the beginning of Mr. Hughes buying up Las Vegas. He bought the El Rancho that week. He bought the Silver Slipper that week. He just started buying up things. It amused him. He also didn't like the mob. That was his way of getting rid of them: he bought up everything.

One night years later, in the early 1960s, I met Mr. Hughes in the Beverly Hills Hotel, going up in an elevator.

"Hello, Debbie," he said.

"My goodness, Mr. Hughes," I said. "Do you live here now instead of the Desert Inn?"

"I go back and forth," he said. "I have a suite here and a floor in Vegas."

He was very hard of hearing but he was a sensitive man, a Jimmy Stewart type.

After he died, Terry Moore sued Mr. Hughes's estate, claiming that they were married on a yacht in international waters off Mexico in 1949, and never divorced. Mr. Hughes had told me that it wasn't true. He said he'd told Terry they

could be married by the captain, which was him. But it wasn't a real marriage. He'd checked it out, and they were never legally married. He liked intrigue. She was holding up the whole estate, so they paid her off for "an undisclosed sum." But I believe it was about $700,000. Terry wrote a book about it, *The Beauty and the Billionaire*. It became a bestseller in 1984.

I found Mr. Hughes to be the most polite, southern Texas kind of gentleman. He was smarter than anyone else I knew. He should have had a happier life.

THE FOURTH GABOR

Before we had the Kardashians, we had the Gabors: Zsa Zsa, Eva, Magda, and their mother, Jolie. Although the Kardashian gang are merely famous for being famous and for a notorious sex tape, some of the Gabors were actually actresses. But then, when the Gabors were young there were no lightbulbs, let alone videotapes.

Once upon a time in a faraway land called Hungary, there lived a beautiful woman named Jolie Gabor, the daughter of wealthy Jewish jewelers who owned a store called the Diamond House. Jolie had three beautiful daughters who grew up believing they were princesses, if not by birth, at least by entitlement. The girls in this family

were famous for their jewels and their many marriages. They were always getting married or divorced, slapping policemen, or getting themselves in the headlines for something silly—great material for comics, who never failed to use it. But that came later.

Mother Jolie was a good businesswoman. She moved the family to the US in 1945 and soon opened a jewelry store on Madison Avenue that was very popular in the New York social scene. She used to give big parties at her apartment. Jolie would play the piano and her lover, Edmond, would play the violin. She'd brought Edmond to the US from Hungary. According to her, he was a freedom fighter. Jolie insisted that Eva and Zsa Zsa buy town houses in Manhattan. They later sold them to the government for a huge profit, to be used for housing ambassadors and such. They became very wealthy thanks to their mother's advice.

Jolie used to call me the Fourth Gabor because I looked like I could be one of her daughters. Also, I could sound like them. At MGM, I'd been able to screen movies to study the techniques of the great actresses. I noticed how Bette Davis held her hands during a scene, how Garbo used her beautiful voice. When I began doing a nightclub act, I used my natural ability to mimic voices to do impressions of famous stars, everyone from Jimmy Stewart to Zsa Zsa Gabor. Agnes Moorehead had coached me when I was developing a character. "It's where they place their voice, where they put it," she would say. When I started doing my

impression of Barbra Streisand in my act, it was difficult to learn because the placement of her singing and speaking voices is so different. When she sings she produces these magnificent, full, chest and head tones. But when she talks it's nasal, filtered through Brooklyn. My Gabor impressions have been a staple in my act from the beginning. Eva had a slower, more melodic tone. Zsa Zsa was always high-strung, sounding hysterical. Her voice was a few tones above Eva's. I would use Zsa Zsa's line about being a great housekeeper. Every time she got divorced, she'd keep the house.

Whenever I was the mystery guest on the television quiz show What's My Line? I'd disguise my voice by answering the panel's questions with my Hungarian accent. In one of my early TV specials, I did the impression as "Ga Ga Zabor." Carl Reiner wrote the skit. I once dressed up as Eva on a Bob Hope special, all in chiffon and feathers with lots of shimmering diamonds.

The Gabor sisters were fun to imitate. But I could never be like them in real life.

The oldest was Magda, a socialite who didn't get involved in acting. Zsa Zsa was born two years after Magda. She almost became Miss Hungary in 1934, but was demoted to runner-up because she was a year underage. Jolie and Zsa Zsa consoled themselves with a shopping spree in Vienna, where Richard Tauber, one of the most renowned tenors in Europe, approached them in a restaurant and asked Zsa Zsa to be in a new operetta he'd composed and

was starring in. After its three-month run she returned to Budapest restless. So she went to Istanbul, and asked a Turkish diplomat to marry her. ("I want to choose the man. I do not permit men to choose me," she states in her autobiography.) That was how Burhan Belge became the first of her nine husbands.

By the time Zsa Zsa's first movie was released by MGM in July 1952, she'd already gone through her second marriage (to Conrad Hilton; she also had an affair with his son Nicky) and was about halfway through her third (to George Sanders). She would come to exercise class wearing a black leotard and all her jewelry—rings, strands of pearls, bracelets, earrings; everything but a tiara. It was exercise just lifting those gems!

Ask Zsa Zsa to a party, any party, and if the refrigerator door opened, the lights went on, and Zsa Zsa was in the right spot, she would go into her routine: "I'm happy to be here, darling; the whole world loves me; I'm having such a good time." She didn't sing but she would do a speech. It didn't matter to Zsa Zsa that nobody applauded. She was on.

Sometimes Zsa Zsa was just too much. Once I gave a dinner party at my home for several friends, including Jimmy Stewart and his wife, Gloria, and Groucho Marx. Zsa Zsa was there with her spouse of the moment, Herbert Hutner. She didn't do her routine that evening. Instead, while everyone chatted, Zsa Zsa loudly criticized Husband Number Four, saying things like "Why are you so boring?"

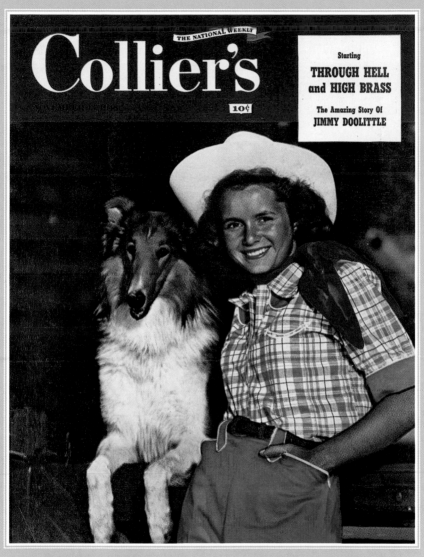

My first professional photo, at sixteen. I had just won the Miss Burbank
contest, which led to my first studio contract, at Warner Brothers.

Phyllis was one of the original women to break into comedy
in a big way. Always outrageous and funny, she was a great friend
who understood the value of a good martini.

When I started at MGM, Lana Turner was one of their biggest stars.
She loved and lived big. As graduates of the studio system, we shared a lot.

Bette always called me "Daughter" after playing my mother in
The Catered Affair. This photo was taken at the taping of a television
program honoring makeup artists. Good company, dreadful evening.

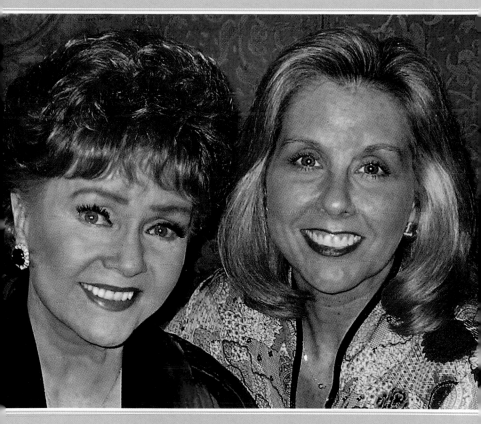

My dear friend Jen. She was a Texas gal with a big heart,
great looks, and a soul that thrived on adventure. Every life she touched
was made better because of her friendship.

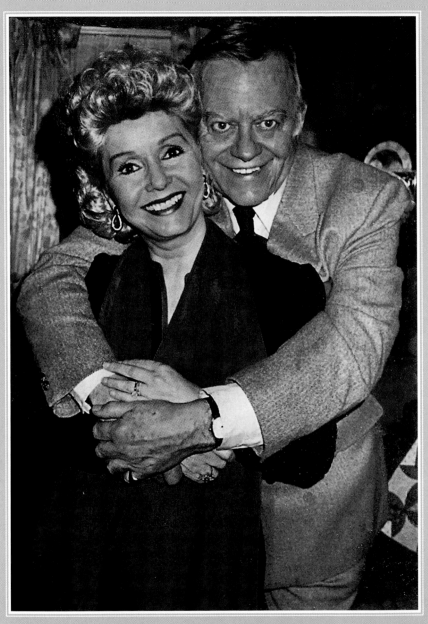

With my friend Max Showalter. He produced a film festival in Connecticut, where he introduced me to the legendary Katharine Hepburn.

Katharine Houghton Hepburn

VII-19-1986

Dear Debbie
You did a really
fine job that night.
Any ass can handle
a big crowd—But
you just made a
really tough situation
work. Bravo!

Kate Hep

This is Miss Hepburn's note to me. I had written to her requesting a signed photograph. I love it that she signed it "Kate Hep." It makes me feel special.

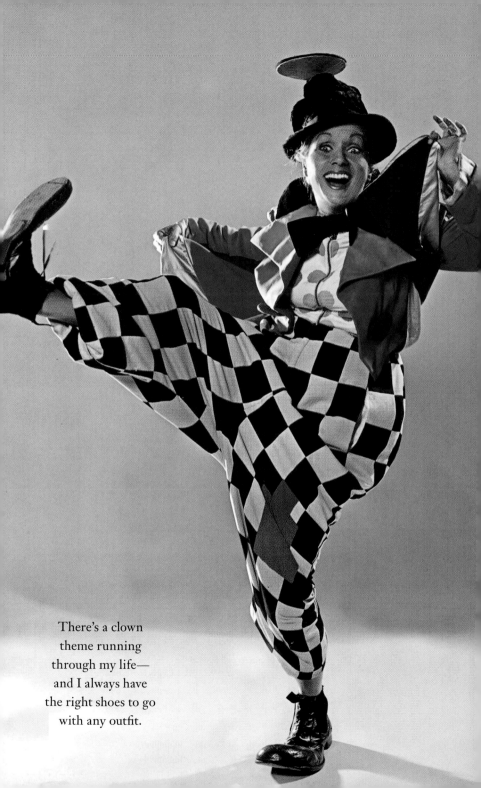

There's a clown
theme running
through my life—
and I always have
the right shoes to go
with any outfit.

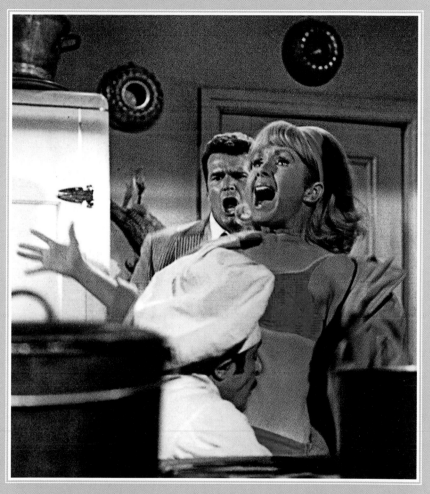

Always going for the joke, this scene from *How Sweet It Is* has me flashing my blue bikini while asking, "Is this the body of a middle-aged mother?" Looks like the chef thought I was the catch of the day.

My son, Todd, with his canine soul mate, Yippee.
This old pup decided to take a dip in my bathroom spa on Mother's Day.
Luckily I was able to rescue him.

Todd with his other soul mate, the lovely Catherine Hickland.

At the South Point Hotel in Las Vegas in November 2014.
My granddaughter, Billie Lourd, made her nightclub debut as
a featured guest in my act.

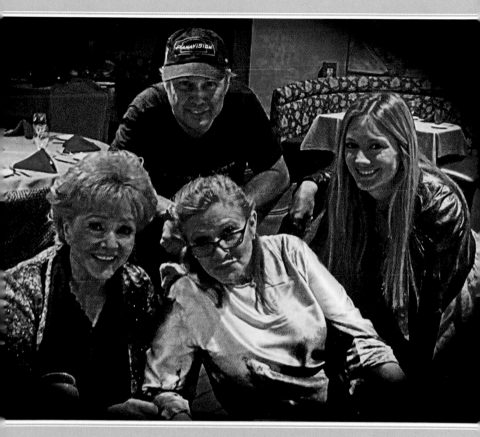

We made it through three shows together!

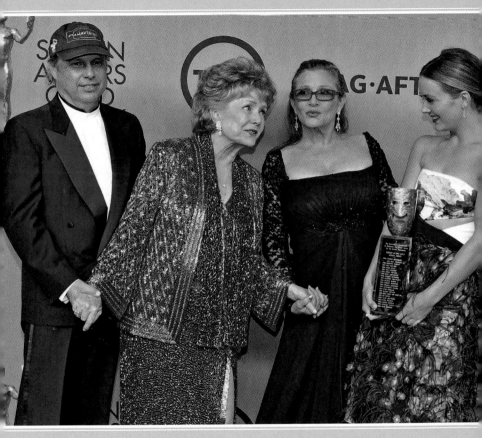

After I received the SAG Lifetime Achievement Award,
my family joined me backstage.

PH: Theo Wargo / Wireimage.com for Turner Entertainment Networks.

My granddaughter, Billie, had just been cast in *Scream Queens*.
I'm so happy she is enjoying her new acting career.

PH: Kevin Mazur / Wireimage.com for Turner Entertainment Networks.

I commissioned this portrait from a very talented Florida artist named
Ralph Cowan as a birthday gift for my husband Eddie Fisher.
Eddie left me before the paint was dry.

and "Why can't you be interesting like everyone else?" I was horrified. She was so rude to him that I finally went over to her.

"My driver will take you home now," I whispered in her ear. "Just get your things and leave."

Herbert seemed relieved to be going. He was always sweet and polite.

After five years of marriage George Sanders left her. They were planning to go out for the evening. Zsa Zsa was never on time for anything. She'd spend hours getting herself ready. She was at her makeup table primping when George appeared in the bedroom doorway.

"I'm leaving," he said.

"Wait, darling. I'll just take a few more minutes."

"I'm leaving," he said again, and turned and walked out of the house with the two suitcases he had packed and ready.

I'm told Zsa Zsa was very surprised an hour later that she was in the house alone. I guess she didn't hear the door close behind him.

Zsa Zsa later advised George to marry Magda, as she would take care of him, whereas Zsa Zsa never did. George actually did marry Zsa Zsa's older sister, but they had their union annulled after two months.

George Sanders was a brilliant actor who is possibly best known for his role as Addison DeWitt in the 1950 film *All About Eve* with Bette Davis. Having performed in many

movies, married four times, and being respected in the business, he committed suicide. George swallowed a lot of pills and lay down naked in his bed, covered in cash. He left a note saying in part, "I'm leaving because I'm bored." It's hard to imagine what else he needed to have for excitement.

When I was filming *Behind the Candelabra*, the producers used Zsa Zsa's residence as a location for Liberace's house. I would have liked to go up to visit with Zsa Zsa. She's been so ill for so many years that I didn't think she would recognize me dressed as Liberace's mother with a white wig and prosthetic nose. Even my son didn't recognize me when someone sent him a picture of me in that wonderful makeup.

Jolie's youngest daughter, Eva, was my favorite in the family. We became friends in 1959 while filming *It Started with a Kiss* on location in Spain. In the 1960s Eva costarred in the hit TV series *Green Acres*.

Eva and I were very close friends. Sometimes when I drove around town after the kids were in bed, I'd stop at Eva's to visit. If she was busy entertaining a gentleman friend, she would shout out to me, "I can't see you now, darling, I'm all tied up." I'm not sure if she meant this literally, but I got the message that she was "occupied."

The Gabors were also famous for not remembering how old they were. Zsa Zsa said she was fifty for at least twenty-five years. Eva used to say, "I believe in loyalty. Once a woman finds an age she likes, she should stick to it."

Jolie (the mother of all Gabors) used to call me the Fourth Gabor. Here I am with Eva, my closest friend out of that bunch of crazy Hungarians!

The gossip columnist Cindy Adams was a friend of Jolie's who helped write her memoirs. In October 2007 Adams told *Vanity Fair* magazine about an incident that happened when she and Jolie were working on the book.

> Eva was getting married to her 44th husband, and the wedding gown was very décolleté. Between the fleshly hills of Gabor was a cross larger than St. Peter's Basilica. The Gabors were Jewish, so I said to Jolie, "What's with the goddamn cross?" Jolie said, "Eva's new about-to-be-husband hates the Jews, so in this book you make us Catholic."

Actually Eva was married only five times. But you've got to hand it to the Gabors: they lived life on their own terms.

...

Telling you about women who knew what they wanted and got it reminds me of someone who wasn't really my friend but who was "close" to someone who was: George Eiferman. My friend George was part of this woman's revue in the 1950s, along with several other titled bodybuilders. He went on to become Mr. Universe in 1962. George was living and teaching in Las Vegas when I first met him, and owned a lot of health clubs there. He was the perfect choice to perform with me when I added an impression of his former employer to my act.

...

GIVE A MAN A FREE HAND AND
HE'LL RUN IT ALL OVER YOU

Mae West was one of the first women to break through in comedy. Gifted and provocative, she wrote her own material for her performances on the vaudeville circuit and Broadway. In the 1920s, she wrote a play called *Sex* in which she starred. The most famous thing about the show was that she and the Broadway cast were arrested on morals charges. Mae bailed out her company but spent

eight days in jail herself. She told the press she'd worn silk underwear the whole time she was there. The play ran for nearly a year.

Mae had an eye for talent of the male persuasion. She cast a young Cary Grant to star with her in her first movie, *She Done Him Wrong*, which gave him a boost. After her film career ended, she performed in Las Vegas with a collection of eight former Mr. Universes and other bodybuilding titleholders, including Steve Reeves. (Steve had a successful film career playing beefcake roles like Hercules in two hit movies. He also appeared with me in one of my less successful efforts, *Athena*. Another blonde bombshell, Jayne Mansfield, married one of Mae's other musclemen: Mickey Hargitay. Their daughter, Mariska, is the wonderfully talented and successful star of television's *Law & Order: Special Victims Unit*.)

When I was preparing my impression of Mae West for my stage show in the early 1970s, I was fascinated by her and wanted to find out how she had learned so much about life. She was independent and brilliant, and created her own career. When I changed into my Mae West drag, I would sing "Some of These Days." At one point, I'd pick up a chain that stretched across the stage and reel it in. At the end of the chain was my friend George, his muscles oiled and glistening, dressed in bathing trunks, leather gladiator sandals laced to midcalf, and a big smile, with the chain wrapped loosely around his neck. When he reached me at

center stage, I would playfully look him over while doing my impression of Miss West.

I took George with me when I brought my show, *Debbie*, to Broadway in the fall of 1976. I changed my costume for that engagement because of something George told me. Apparently Mae had heard that I wore a red gown when I did my impression of her, and her response was classic.

"I nevah wore red. Hookahs wear red and Mae West was nevah a hookah."

So I changed it to a black gown. I love impersonating her, because I can say things as Mae that Debbie Reynolds would never say.

Such as "You know, sex is like bridge. If you don't have a good partner, you'd better have a good hand."

Or "Sex is like air. It doesn't seem important until you aren't getting any."

Mae certainly got her share. She loved the attention of men and relished sexual adventures. She lived in a beautiful apartment building in Hollywood called the Ravenswood on Rossmore Avenue. At one time, she had a lover who was a prizefighter. The other tenants in the building didn't care for his frequent visits because he was an African American, and teamed up to ban his visits. That didn't stop Mae. Just like Howard Hughes, she simply bought the building, and that was the end of that.

As Mae said, it's not the men in your life, it's the life in your men. Mae had men every day, around the clock.

Come up and see me sometime. Mae West was a true original—
a brilliant writer as well as a great businesswoman. Here I am with
George Eiferman, doing my impression of Miss West.

Happiness around the clock. She would say they "enjoyed" each other.

In the 1960s I was working on the Paramount lot at the same time Audrey Hepburn was doing a film there. Wally Westmore was the studio's chief makeup man. When Wally was working on Audrey and me, he didn't care what we asked for.

"Whatever you need is fine," he said. "You girls don't ask for anything compared to Mae West."

And he told us about when Mae had to do scenes in a nude net dress.

By that time her chest was low, so Wally made a plaster-of-paris bustier for her to wear under her dress. She posed in the nude so he could slather her with wet plaster to get the mold. Then she insisted that he make her nipples long and pointed, so they would "read" on camera. Wally took a file and spent a lot of time working on Mae's plaster nipples. He worked on them for days, but couldn't make the nipples long enough or sharp enough to suit her. So she sat and filed them herself.

That was Mae West. She was unique. No one since has ever matched her (although I do my best to show how remarkable she was in my act).

...

Now I'll get back to my friends. I just couldn't resist telling you about Miss West. I'll start with some of my co-median buddies who aren't in that picture in chapter 5.

...

"IF YOUR SHIP DOESN'T COME IN, SWIM OUT TO MEET IT."

Jonathan Winters heard voices. Happily he shared them with all of us. He was unique in a way that few comedians could

be. Robin Williams adored him. You can see Jonathan's influence in Robin's crazy brand of humor. It's the same voices filtered through a different genius. The only other comedian I knew who truly heard voices was Wayland Flowers. To him, the voices of the characters he created spoke to him just as Jonathan's and Robin's did to them.

Jonathan found the love of his life in a wonderful woman named Eileen. She had electric-blue eyes and a fabulous sense of humor. She was so tuned in to him. She never got bored when he'd retell his stories about creatures and cartoons and caricatures that he came up with. She was the perfect mate. They were lovely together.

Whenever I gave dinner parties, there were two people that everyone tried to sit next to—Jonathan and Jimmy Stewart. Everyone would scream at Jonathan's funny lines. Jimmy was so opposite, but charming. Each of them was compelling in very different ways.

Once I was at a party where I was seated at the same table with Jonathan and Thelma Ritter. Usually I feel the need to be entertaining when I'm around people, but not that night. All I did was hang on for dear life around those two. The air was thick with their funny lines. Jonathan was on all the time, but it wasn't obnoxious like Milton Berle, who always had to have a loudspeaker. Jonathan just enjoyed sharing his funny scenarios and characters, which changed on the spot.

Jonathan was a favorite on television shows. Johnny Carson loved him. Many of our other comedians consider him their greatest influence, people like Bob Newhart, Jim Carrey, and Steve Carell. He loved jokes. I used to call him whenever I heard a good one.

Jonathan collected toys; the Winters home was full of stuffed animals and toys of all types and kinds. He loved toy soldiers. When MGM auctioned off everything on their lot including the lot in 1970, I bought a set of toy soldiers used in the film *Marie Antoinette* to give to Jonathan. He and Eileen were living in Toluca Lake at the time, in a lovely old colonial house right near a golf course. Jonathan was so thrilled with the gift that he thanked me a million times over.

Jonathan and Eileen later moved to the Santa Barbara area. They were active in the community theater there. They asked me to bring my act to this beautiful old brick playhouse with wood pilings, which I was happy to do. After my two shows that night, Jonathan and Eileen gave me a big party.

One evening I drove up to visit them and we all went out for dinner to a restaurant on the main thoroughfare. The food was really good. Jonathan loved an audience, and somehow included the tables around us, people he didn't know, in our dinner party. He was so funny that everyone was entertained for the hour or two that we were there.

Eileen died of cancer in 2009. It was very sad when she

went first. Jonathan would go to the market twice a day, just to have an audience. He wanted to always entertain and he entertained to the end, even though it wasn't onstage. But he had lost his best audience. His daughter lived nearby and the family was very close, so I know they took good care of him until his death in 2013. He was truly a treasure.

SLEEPING WITH A MADAME

"Good eveeening!"

Her voice rings out—half southern belle and half drag queen doing Ethel Merman.

"My name is Madame. This fellow over here is Wayland Flowers. You may have noticed that Wayland is not a ventriloquist. But that's all right, because *I* am no fucking dummy! Ha-ha-ha-ha-ha!"

Stick-thin arms raised in glee, feathers flying, Madame's laugh bends her backward as the audience applauds wildly. She sits up, her jewels sparkling in the spotlight, and fondles her fur wrap for a moment.

"Like my fuzzy? It's from Dicker and Dicker. This one looks like it's been dicked to death."

And she's off again, the audience with her all the way, her staccato laughter contagious. By now Wayland, standing

On the set of the 1980s comedy Madame's Place, *with the star herself. Her best friend, Wayland, was so dear to me.*
Carol Hannaway

beside and just below Madame at the edge of the spotlight, is invisible. No one is looking at the puppet's boyish blond manipulator, or noticing that he is average height, barefoot, in slacks, a white shirt, and rainbow suspenders. All eyes are on Madame.

It was easy to fall in love with Madame—and her creator. Like Jonathan Winters and Robin Williams, Wayland Flowers was in a special class. He actually heard voices. Some say this is a sign of schizophrenia. (Is it possible that comedy and

fragile mental health are so closely related?) In Wayland's case, I believe the things he heard made him unique as a performer. Puppets spoke to Wayland, and Wayland spoke through them.

Wayland would disagree about calling Madame a puppet, however. She was a very real person to him. She always dressed in glittering gowns and jewels. She loved hats and turbans—with feathers, the bigger and showier the better. Her tiara was always nearby. She was only three feet tall, but her voice could shatter glass. As often as not, she used it to shock people as well as make them laugh.

Sometimes Madame would interrupt the show to ask for a glass of water for Wayland.

"How did you know I was thirsty?" he'd ask.

"Your hand is dry."

"Would you like some?" he'd offer.

"I never touch the stuff," Madame shot back. "Fish fuck in it!"

It was an old W. C. Fields joke but that's okay. Comedians all "borrow" from one another.

How to describe Madame to someone who's never seen her? Basically she's a hand-and-rod puppet, with a big head made up of extreme angles—a long pointy nose jutting out between tennis-ball cheeks above an equally long, knobbed chin. Huge eyes. Her arms had wooden dowels so they could bend at the elbows, and rods attached to tiny hands that Wayland operated ingeniously with his own

amazingly nimble left hand. Most people find working with two rods too difficult. To Wayland it was second nature; he never needed instruction. Wayland himself was slender, with delicate wrists that fit nicely into Madame's tiny neck while his right hand operated Madame's wide, astonishingly expressive, lacquered mouth.

Wayland hailed from a small Georgia town called Dawson that was so far south the natives used to call Atlanta "Yankee Country." Raised from a toddler by his mother and aunts after his father's death in World War II, he loved singing, and playing with dolls with his sister, Frankie. He was mesmerized by MGM and Fox musicals, and identified with stars like Ginger Rogers, Betty Grable, and Mae West. As soon as he figured out where he was, he left. He couldn't wait to move to New York. There he worked for Bil Baird, the famous theater and television puppeteer, and learned to build puppets. He begged Jim Henson for work before Henson himself became famous, but Henson turned him down.

He got a job operating a witch puppet in a *Wizard of Oz* show at the 1964–1965 New York World's Fair. When the fair closed, his boss gave him the puppet. She hung on a wire hanger in Wayland's closet for a long time, staring at Wayland whenever he opened the door. Finally he gave her a name. They entertained in bars in return for drinks. Then Andy Williams put Wayland and Madame on one of his television specials. They did some other programs, and then producer George Schlatter put them in his 1977 revival of *Laugh-In*.

(George had a great eye for comic talent. The show also starred Robin Williams, who was then unknown. George is an exceptional man. He helped launch so many careers with his *Laugh-In* comedy shows. The first series introduced Lily Tomlin, Goldie Hawn, Ruth Buzzi, and many others.)

Then Wayland and Madame took over the prized center square on the big *Hollywood Squares* tic-tac-toe board, after Paul Lynde left the show. I'm not sure if it was a requirement then that the center square be a gay man. Actors and comics such as Phyllis Diller, Charlie Weaver, and Vincent Price filled the eight remaining squares. Everyone made up funny responses to host Peter Marshall's questions before giving their real answers. All I remember about that show is the grueling shooting schedule—the whole week was shot in one day!—and those narrow spiral stairways to the top squares. Going up and down was a nightmare.

I was lucky to meet Wayland in his early days, before he became truly famous, when he was still performing in clubs. I first saw him during one of his gigs in Los Angeles, in the mid-1970s. After the show, I went backstage to say hello. We wound up sitting and talking for hours.

Wayland and I became fast friends. Sometimes we performed simultaneously in the same city. He often played the Sahara or the Sands hotels in Vegas while I was at the Desert Inn or the MGM Grand. Madame used to say, "Vegas isn't the end of the world, but you can see it from there."

I loved Madame so much that I decided to become her in my act. I'm always updating it with impressions of stars I admire such as Mae West, Barbra Streisand, my friends Phyllis Diller and Bette Davis.

It was 1981. By then Wayland was playing the large rooms in casinos as well as appearing regularly on television. I hired two of his writers to work on my Madame material, and his puppeteer to create a Madame mask. Madame's seamstress designed my sequined gown. I found a small, blond doll to represent Wayland that we dressed in a little suit.

I tried out the material at the LA Comedy Store on Sunset Boulevard. I began as myself, singing Stephen Sondheim's "I'm Still Here" from *Follies* with special lyrics I wrote. Then I went backstage to change into Madame. Halfway into my routine, the crowd suddenly screamed with laughter. "This is working great," I thought. But the audience kept cheering even when I wasn't doing anything.

A small hand tapped me on the shoulder. I could hardly see through the rubber mask that covered my head. I spun my head around to find out who was touching me. All I saw were feathers. *Pink* feathers.

It was Madame herself. She and Wayland had come to see what I'd put together with their people, and Wayland couldn't resist the urge to join me onstage. The three of us bantered for several minutes before I went back to my act. The crowd loved it—and so did I. How did I feel about being upstaged? It was a tryout, to see what worked and what

didn't. And as a performer, I'd learned early to rely on my old Girl Scout motto—"Be prepared!" For anything.

One summer around that time we were both appearing in Lake Tahoe. I was staying at the Harrah's guesthouse, a large stone building by the edge of the lake. Wayland was playing at the Sahara. After a long week of shows, we were ready to party. So I invited Wayland and his crew to join my musicians, dancers, and the rest of my tour gang at my place. The guesthouse was huge and elegant, but rustic. Downstairs was the living room lined with banquettes, with a stone fireplace as the focal point and a stairway made of tree trunks to the left—the ultimate party place.

We all went back around 1:00 A.M. Everyone danced, told jokes, and had a good time. Wayland brought his musical director, Gary Simmons, his road manager, and a few other friends. How did they stay so skinny? I wondered. It must have been the diet so popular at the time—drugs and disco dancing.

My hairdresser, Pinky, loaned Wayland her bathing suit so he could swim in the pool. Wayland was a mere slip of a thing, and the suit was too big. So he tried wrapping it around his waist to keep it from falling off. He should have just stayed underwater.

At 4:00 A.M. I decided to turn in, and slipped upstairs to my bedroom. I was in my pajamas under the covers when I heard a knock on the door.

"Come in," I said without getting up.

Wayland entered, with Madame on his arm.

"Hi, Debbie," he said. "Are you going to bed now?"

I laughed.

"Yes, dear. Do you need something?"

"Can I sleep with you?"

"Both of you?"

I wondered how he would get any rest with Madame on his arm.

He giggled.

"Yes, but I've never slept with a woman before, except for Madame."

"Well, dear, that's all you'll be doing. Sleeping. It shouldn't be too difficult."

I motioned him to the bed.

"I'm going to stay on my side, under the covers. You and Madame stay on your side of the bed, on top of them."

I was surprised to see him blush (maybe because he'd been drinking).

Wayland lay down with Madame's head next to his between us. A rhinestone sparkled in the middle of each of her wide eyes under her large eyelashes. I should have given her one of my sleep masks so she wouldn't be staring at me all night.

In the morning, the maids from Harrah's knocked on my door. Wayland was still sound asleep. Madame was still staring at me. The ladies were a bit surprised to see me in bed with a puppet and a man lying on top of my covers. I wasn't dating anybody at this time in my life so a man in the bed was a

novelty. I have no idea what they thought about Madame, but I'm sure it gave them something to talk about over lunch.

Wayland looked angelic, sleeping in his clothes with his tousled blond hair on the pillow, more like a youngster than a man in his forties. A few years later, we lost this great talent to AIDS. Sleep well, dear friend.

...

...

A FAMILY FAVORITE

Don Rickles is famous for insulting his audience to make them laugh. He developed his comedic style by talking back to hecklers, before he became famous. He didn't do a lot of jokes, but played off the audience. In the late 1950s and early 1960s Don used to play clubs in New York and Miami, but I usually caught his act in LA, somewhere on La Cienega Boulevard. I'd always sit in the front, by the stage, and Don used to go after me, saying outrageous things like "Eddie Fisher married to Elizabeth Taylor is like me trying to wash the Empire State Building with a bar of soap." I found it very embarrassing. Finally I had to ask him to stop.

When he noticed Frank Sinatra at one of his shows, he treated Frank like everybody else.

"Make yourself at home, Frank," Don said. "Hit somebody."

Don used to joke about Jilly Rizzo, who owned a famous nightclub in Manhattan where Frank hung out when he was

Don waving good-bye after his last appearance on The Late Show with David Letterman. *You gotta love this guy.*

in New York. They were very close friends. Don would say that Frank kept Jilly around to check for bombs under his car.

Frank loved Don. Everyone who knows Don loves him. He's the sweetest. He was so dear when we worked together in *The Rat Race* in 1959, and surprisingly very shy.

Some comics keep a clock onstage when they perform, to let them know when it's time for intermission. Don has his own inner time meter.

When we both performed in Tahoe, we stayed in houses next to each other that were separated by hedges. After

our shows, instead of sitting up together, we tossed empty wine bottles over the hedges while yelling at each other.

"Do you want a drink? Here's some Chablis."

"Thanks, have a Merlot."

Don recently was renewed at the Orleans Hotel in Las Vegas for two years. He says his doctor wants him to keep working.

"Which is fine," he told me. "I love working."

I just had to tease him.

"Of course you love working. You're ugly. You don't have a hair on your head. All you have to do to get ready is put on your suit. Do you know how much work it is for me to get into a gown, do my makeup and hair, go over my lines, and warm up to sing and dance? Hockey pucks don't need makeup."

Then I added the punch line.

"And you're funny as shit."

I really do love Don.

...

...

HOUSEWORK WON'T KILL YOU, BUT WHY TAKE THE CHANCE?

Phyllis Diller used to say the following about mealtime: "I serve dinner in three waves. (1) Serve the dinner. (2) Clear the table. (3) Bury the dead."

No one can ever accuse me of cooking, but I have

Watching the sunset in Malibu with Phyllis Diller.
Did we laugh all the time? You bet!

a wonderful assistant who does. Phyllis loved Donald's shepherd's pie, and would ask me to bring some whenever I visited her for dinner. Donald always was happy to oblige.

Going to visit Phyllis was a blast. A long driveway led from the gate through the grounds, with enormous trees on either side spectacularly lit by John Watson, whom *Time* magazine named "Mr. Moonlight." He calls his designs "Moon Shadows," and they can cost thousands of dollars. He has also worked for Johnny Carson, Kenny Rogers, Willie Nelson, a Saudi prince, and many other famous people and institutions.

Phyllis's beautiful home was a sharp contrast to her comedy material about housekeeping. She had names for all her rooms. Her music room/office was the "Bach Room."

The powder room was the "Edith Head," with a sketch of a gown designed by Edith Head in it. The foyer to her sitting area was the "Loggia." To the left of the foyer was the "Bob Hope Salon," named for her mentor. She had a telephone room she called the "John Wilkes Booth." Phyllis would escort me and the shepherd's pie to the "Scarlet Scullery"— her kitchen—which had vivid red walls and appliances.

After dinner Phyllis would play the piano, often yelling at me over the music to dance for her. If her friend Karla was there, at around 9:00 P.M. one of us would suggest going to Shutters Hotel to listen to their jazz trio. Karla would drive us to the beach at Santa Monica. Sometimes Phyllis and I danced together in front of the bandstand. Other times I'd sing along to the standards they played. It didn't take long for people to realize I was doing a show. Drinks would arrive at our table. At closing time Karla, Phyllis, and I would rummage in our purses for cash to keep the band going another hour.

Here's Donald's recipe. You really should try it.

Donald's Shepherd's Pie
Makes approximately 8 servings

6-7 medium Yukon Gold potatoes
3-4 quarts salted water
½ cup milk, or more as needed
2 tablespoons butter
½ medium red pepper, chopped

½ medium green pepper, chopped
½ medium yellow onion, chopped
1½ pounds chopped sirloin
Seasoned salt
One 15-ounce can cream-style corn
One 15-ounce can tomato sauce
½ cup shredded cheddar cheese for topping

Preheat oven to 350 degrees.

Peel and dice the potatoes and boil them in salted water until tender. Drain and mash the potatoes, adding milk as needed for a smooth consistency. Stir in butter, and salt to taste. In a skillet, sauté chopped peppers and onion until tender. Add chopped sirloin and sprinkle with seasoned salt to taste. Cook thoroughly.

Stir corn and tomato sauce into cooked meat mixture.

Spoon half of the mashed potatoes into the bottom of a baking dish and pour meat mixture over potatoes. Cover the meat mixture with the rest of the mashed potatoes.

Spread the shredded cheese over the top of the potatoes. Bake in the preheated oven for 30 minutes.

Call Phyllis so she can start shaking the martinis she loved so much.

Drive to Phyllis's house as fast as possible to serve hot.

...

Now let me tell you a little about this wonderful man.

THE MAX TO MY NORMA

At MGM we were taught to value our fans. When I received fan mail, I answered every letter. Sometimes my mother would help me.

One of my most ardent fans was a lady from New Jersey named Agnes Light. Agnes in turn taught her son, Donald, all about his mother's favorite star. How lucky for me that she felt that way. Donald, too.

On a trip to California in the early 1960s Donald tried to visit my address, which was listed at the time as 120 El Camino Drive in Beverly Hills. That was actually the address for a business office right down the street from my agents at William Morris, whose office was at 151 El Camino. Donald was very disappointed to discover that I didn't live on that little street right behind the Beverly Wilshire Hotel.

But he continued to correspond with me. In one of my letters to him, I actually used my real address, 813 Greenway Drive in Beverly Hills. On their next trip to Los Angeles, the Lights stopped by to see my house. They peeked around the front, where there wasn't a lot visible from the street. While they were poking around hoping to catch a glimpse of their star at home, Agnes discovered some ivy in front of the house. She reached in her purse, pulled out a pair of scissors, and took a cutting of the ivy to keep as a souvenir. When Donald and his mother got back to their hotel, she put the cutting in a glass of water until it rooted. (They were

there for a week or so.) She then packed it carefully in a wet paper towel, put it in a plastic bag, carried it all the way back to New Jersey, and planted it in her yard, where it thrived.

The first time Donald came to see me perform live was in the late 1960s when I appeared at the Garden State Performing Arts Center in Holmdel, New Jersey. He and his friend Lillian, who worked with him at Valley National Bank, got tickets for my show. At that time I was working with a cast of twenty-five people, including Carrie and Todd. After the show Donald and Lillian waited in line for my autograph outside the stage door. They kept letting people ahead of them so Donald could watch me longer. He noticed that sometimes I kissed someone on the cheek after I signed the program. Donald is usually very shy, but seeing me do this made him bold. When he and his friend finally reached the front of the line, he asked me what he had to do to get a kiss.

"That's easy. Do you want a kiss, dear?"

I was happy to give him a peck on the cheek along with my autograph.

On March 13, 1973, my musical *Irene* opened at the Minskoff Theatre on Broadway. Donald was there that night, hoping to get a ticket for the sold-out performance. He waited near the box office for any held-back tickets to be released. Also waiting at the box office was a stewardess. She told Donald that this was her only night in town and she was anxious to get a seat. The box office had only one ticket to release. Donald let the young lady have it. He's such a gentleman.

Then Donald waited outside the theater, hoping to see me after the show. As the audience streamed out, the stewardess came to find Donald.

"They're doing something onstage," she said, "You should come in."

Donald couldn't resist. While everyone else was leaving, he and the stewardess went back into the Minskoff. From their spot near the orchestra pit, they could hear the cast and crew laughing and talking backstage. After a while Donald said they should leave. He took up his post outside the theater waiting to see me. His moment came when I left through the lobby, down the sixty-foot escalator to the doors on the ground floor, on my way to the opening-night party across the street at Sardi's. Donald remembers me wearing a black velvet dress. So do I—it was a Halston.

Donald didn't approach me that night, nor on any of the many other nights he came back to see *Irene* and waited at the stage door afterward to see me. He would always hold back and watch while I chatted with other people who had seen the show. But I noticed him, and after a while I encouraged him to join us, and then we'd say a few words to each other.

That finally changed in April. My children were staying with me at the town house I rented while I was doing *Irene*. Todd accidentally shot himself in the leg while playing with an antique prop gun I had bought for my memorabilia collection. (We're prone to drama in this household.) I took Todd to the

hospital and called to tell Carrie to flush all the bullets as well as any of her pot before the police came to search the town house for other weapons. When I got back I was arrested. The incident became front-page news, and some of the papers that picked up the story printed my address.

The next afternoon Donald and Agnes were in front of the town house waiting when I was leaving to do my Sunday matinee. I came out of the house carrying my French poodle Killer. Donald had brought me flowers, along with some of the postcards I had written to him—to prove that I had corresponded with him, that he wasn't just someone who showed up regularly at the stage door. It seems he was too shy to mention this all those times that he had the chance to.

Donald offered us a ride to the theater. He was so polite. I knew he wasn't any danger to me. What stalker brings his mother along? I already had a car to go the theater, so I thanked him and said no.

Donald was not deterred. He continued to pay to see *Irene* and wait at the stage door afterward to chat with me. It was very much like *All About Eve*, where a starstruck youngster waits outside the theater every day for her idol to appear. Thank goodness Donald didn't want to be an actor.

Over the years, Donald would plan his vacations to see me on the road while corresponding with me and my wardrobe supervisor, Stephanie Loren. He visited Denver when I performed the stage version of *The Unsinkable*

Molly Brown there as part of a road tour. One summer he came to see my show at Harrah's in Lake Tahoe. During that visit, I invited him for an afternoon on Mr. Harrah's yacht with Stephanie and me. We spent a lovely time on the lake followed by a nice dinner in my guesthouse. Donald and I were becoming friends.

When I opened my Debbie Reynolds Hotel and Casino in Las Vegas in 1993, Donald came to visit. I planned extensive renovations for the property, which included adding a museum to showcase my beloved collection of Hollywood memorabilia. There was a lot to do; it was so chaotic that I asked Donald to help out. He went back to New Jersey to give notice at Valley National, then returned to Vegas and reported for duty in the basement to work with a man from the Hollywood Wax Museum who was there to help get the mannequins ready for my museum presentation. They slaved away in the sweltering August heat, which would have melted anyone. The only air in that dungeon was from a six-inch oscillating fan. What a glamorous job! But Donald was a good sport. He worked hard anyplace we needed him.

Mrs. Light moved to Vegas in the spring of 1994 to help her son in the gift shop. Donald managed the shop while his mother spent her time knitting. Everyone thought Agnes was my mother, which was just fine with both of us. She had the most beautiful blue eyes.

Agnes moved back to New Jersey when the hotel began to falter. In 1996 we finally had to close it. Donald came to

Los Angeles with me. In addition to working at my dance studio, he's been my friend, companion, and warden. He's been part of the family now for so many years.

Donald loves show business. Back in Jersey, his family is slightly related to Hoboken's favorite son, Frank Sinatra. His father's brother's wife's sister's husband is Ol' Blue Eyes's first cousin. Really.

...

I am so fortunate to have Donald in my life. He takes care of everything. No matter what the problem, he finds a way to handle it. I've been lucky to have exceptional, devoted assistants who are great at what they do. Another was Jenny Alavolasiti, who worked with me for many, many years. I always call her Jen. I never use her last name because I can't pronounce it.

...

PORTRAIT OF JENNY

One of my favorite things about the Las Vegas hotel was unwinding in the lounge following my show in the Star Theater. We called the lounge Jazz and Jokes, named by Rip Taylor, who supplied a lot of the humor in those days. It was open all the time, so people stopped by to hear music and join in the fun. I liked to mingle with the audience.

Jen and her husband, Keith, were on vacation when they dropped into Jazz and Jokes for an afternoon of piña

coladas and music. Jen loved music. She loved great singers of all descriptions, current stars Midler and Streisand but also classic artists like Marilyn Maye and Frances Faye.

Jen was a lovely, tall blonde gal with sparkling blue eyes. Her husband looked like he'd stepped right out of a high school yearbook—a clean-cut, sweet man. They were both teaching school near Jen's hometown of Nacogdoches in East Texas. I sat down with them at their ringside table and we listened to the Jazz and Jokes resident trio. Jen was taken with an antique pavé diamond ring I always wear. As a fellow Texan, I had an easy time chatting and laughing with the couple. They were going to be in Vegas for a few days, so I invited them to come to see my show.

Jen and Keith drove back to Texas in time for the start of the school year. But Jen was feeling the beat of a different drum. The bright lights were calling. She soon gave up teaching and relocated to Las Vegas. Keith and her mother, Jean, came out to visit, but Jen was hell-bent to be out of Texas. Keith supported Jen's decision, even though it meant they spent less time together. He came to visit her whenever he could.

Jen got a real-estate license and moved into a condo in the same complex as mine. As my hotel sank into the desert, Jen was one of the people I turned to as I began to put my life back together. She became a night owl, and we shared some of my famous after-midnight-chat calls. I was happy to have a new friend.

After I returned to live in Los Angeles, Jen started working for me full-time, taking care of all the details in my hectic life. She juggled everything: my travel, packing, scheduling, scripts, contracts, the dog, my kids. There was nothing she couldn't learn to handle. She had a zest for life that made her fun almost every minute. Of course we locked horns occasionally; we were both born under the sign of Aries.

One night we were in a hotel in Culver City for some job when Jen confided in me that I was about to lose my current hairdresser. Sammy lived in Vegas but he would join me on the road when I needed him.

"Why would you say that?" I said. "He's a great hairdresser and he loves show business. Why would he leave?"

"He's going to do Liza."

"He's going to work with Liza?"

"No, he's going to *be* Liza. In a drag show in Vegas."

Sammy was always entertaining us with his jokes and impressions, but this was news to me.

"I didn't know he did Liza."

"He's got a job in *Boylesque*."

Boylesque was a big drag revue that played at different hotels around town.

"Don't worry," Jen said. "I'm learning to do your wigs."

Two shocks in one night.

But darn if she didn't learn how to be a hairstylist in addition to her many other duties.

After years of living in a little apartment, Jen moved

into a rental house next door to my friend Leon, whom I've known since we were seven years old. She and I furnished it with things from my storage units at the studio. We hung my pictures on the walls. It was fun having her so close to Leon.

Jen was happy with her new life. She had the love and support of her Texas family while working with me. She loved her job and she was great at it.

In February 2012, to work on my memoir *Unsinkable*, I rented a place in Tahoe, a three-story house nestled in the side of a mountain overlooking the lake. Todd and Catherine (who was then still his girlfriend) drove up from the ranch with the family dogs Yippee and Dwight. Todd loves to ski and was looking forward to a month in the beautiful mountains. My friend and coauthor, Dori Hannaway, flew in from LA, dragging along reference books, computers, and blank recording tapes. We settled in for a writing retreat combined with a ski vacation for Todd.

Jen took Dwight out for long walks down the mountain every morning. They didn't seem to mind the freezing weather or the altitude. One morning Jen lifted a microwave oven that we'd bought for the rec room out of the car and carried it into the house. In doing so, she hurt her back.

She was in so much pain, she went to an urgent care facility. They prescribed strong painkillers. Although the extreme pain persisted, she wouldn't let us take her to the emergency room. After a few days, she willed herself out of bed to walk Dwight while I was still asleep. In long-distance calls to her

mother Jen assured Jean that she was going to be all right. Keith was worried, but no one could tell Jen what to do.

She handled all the unpacking when we got back to Los Angeles while getting us ready for some upcoming dates. She promised she would go to her chiropractor when she had time. She pushed herself in spite of the constant pain. Finally she went to a doctor my good friend Margie Duncan recommended, who did extensive tests and X-rays.

The news wasn't good. Jen had breast cancer that had spread to her brain and spine. When she'd picked up that microwave, two of the now-fragile bones in her back had broken. Jen was only a few days away from her forty-fourth birthday. Judging by the way the disease had spread, the doctors told her that she had probably had it for more than ten years. She had no reason to suspect it since there was no history of breast cancer in her family.

Jen underwent surgery to put two steel rods on either side of her backbone so she wouldn't fracture it, which could have paralyzed her. Then she began a brave but agonizing journey to overcome her cancer.

If determination could save her, Jen had it in spades. After chemotherapy, radiation, and brain surgery, she still wanted to continue working in spite of what she called her "chemo brain" and sheer exhaustion from all the treatments. Everyone around her wanted to help, but she wanted to keep up with her job.

Unsinkable was published in the beginning of April 2013. As part of my book tour we spent a week in New York, where I made appearances and did interviews. By then, Jen was doing her own wigs as well as mine. On Friday we attended the first preview of *I'll Eat You Last*, Bette Midler's one-woman show about Sue Mengers, written by John Logan. Jen was radiant that night. As the houselights went down, Liza Minnelli appeared on the aisle and slipped into the empty seat in front of us. She was the first person out of her seat at the end, dashing up the aisle to the rear of the house as the crowd rose to give Bette an ovation. We saw her again when we went backstage. Meeting Bette was a thrill Jen had dreamed of for years. Bette took a picture with the two of us, which made Jen's heart sing.

At six the next morning Jen was in urgent care, to make sure she would be able to fly home that night with all the pain and nausea she was having. We did fly back to Los Angeles but Jen wasn't able to work much after that. She still wanted to go on the road but she wasn't up to it. She was afraid that I would "kick her to the curb." Such an irrational fear about losing the job she loved so much. Quite the opposite: I loved Jen and did everything I could to make her comfortable. Keith and Jean moved in for the summer, which turned into fall.

On October 8 Jen lost her valiant battle. She'd been moved back to her house after a long stay in the hospital,

her mother and husband by her side. She left us too soon. Leon and I were right next door, in disbelief that we had lost our dear friend.

Jen would hate being in the spotlight here. She avoided attention. As much as she loved everything going on around her, she thought only of my needs and how to take care of me. When she died, all of her friends were shattered by the loss. How could this happen to someone as strong and vital as Jen? She never had a symptom until her vertebrae cracked from the cancer. So as much as she would hate to tell her own story, I tell it for her. Because I love her and miss her. And because I hope that some other girl in her thirties who has no history of cancer in her family might read this and decide to have a mammogram. It might save you even though you think you're too young or that this could never happen to you.

Jen lived her best life. She followed her heart when she left Nacogdoches, and managed to keep the love of her husband while spending time doing what she loved.

All of us who knew her loved her spirit. She is on to the next adventure.

...

Jen was so young when we lost her. I'm eighty-three years old as I write this, and am thankful that the friends I'll tell you about next all lived longer before they moved on.

THAT'S WHAT FRIENDS ARE FOR

One of the nicest things about working as an actress is making friends. My dearest friend on my 1963 movie *My Six Loves* was Max Showalter. He lived in Laurel Canyon, in a mansion that once belonged to Carole Lombard. His home was on the way to mine, so I would often stop by when I was out driving around late at night. I would throw stones at the window like Cary Grant in *The Philadelphia Story*. Max would answer the door in his pajamas, with his little black French bulldog. He really loved that dog. It was a sweet animal but oversexed—a humper. My leg or any part of the furniture would do for that little guy. Well, he *was* French.

Max enjoyed a long career as a character actor in theater, movies, and TV. He appeared with top women stars such as Susan Hayward, Betty Grable, Carol Channing, Lucille Ball, and twice with Marilyn Monroe (in *Niagara* and *Bus Stop*). And Doris Day. It was while filming *It Happened to Jane* on location with her and Jack Lemmon that he fell in love with the area of Connecticut where he eventually retired. They made that movie in the late 1950s, when Max was appearing under the name Casey Adams.

In addition to acting, Max was a brilliant painter as well as a gifted composer, pianist, and singer. He had two pianos in the living room. He'd play and we'd sing songs all night. He was a Renaissance man. I just adored him.

In 1986 he moved to an eighteenth-century farmhouse in Chester, Connecticut, the same town where Katharine Hepburn lived. He became involved in local musical theater, and wrote, produced, and directed a Christmas musical that played every year somewhere in the state.

Max died of cancer in July 2000. I happened to call him the day before.

"You know I'm dying, Debbie," he said. "We'll have to make this short."

"I didn't know it, Max. You shouldn't have taken the call," I said.

"Your call I will take because we won't be able to talk tomorrow," he responded.

So I said, "Well, Max, don't forget you promised to leave me those porcelain figurines of Napoleon and his soldiers on horseback, for Todd's collection. I'm not asking for any paintings"—his house was full of very expensive paintings—"I just want the five pieces."

I actually reminded him on his deathbed, I was that nervy.

He had a very dear friend, a special friend, named Peter, and Peter sent them to me. That's the kind of person Max was.

When Max first moved to Chester he presented a small film festival there. Miss Hepburn came to this little theater in that long cape she wore all the time, and stayed for the whole evening. After the screening I gave a talk. I told jokes

and tried to be amusing. I came across the letter I wrote when I got back to LA that I hope shows my friendship with Max wasn't just one way when it came to giving.

Feb. 25, 86

Dear Miss Hepburn,

Max Showalter and I were so thrilled that you would find the time to share your day with us in Chester for his <u>little</u> film festival.

Like so many millions you have always been my inspiration, as an actress and courageous woman. We all seem to need a strong image in order to survive certain very difficult times in our lives and you have helped me through a "few" of my moments.

My friend, Max, who is a writer of music, has always loved Connecticut but lived in Los Angeles being an actor also. He is now 69 years and has made this enormous decision to move to Chester, where he knows no one.

I have been told that the residents of certain areas that are small and private do not take to strangers easily, so when Max invited me to help him do this film festival I wanted to be with him so that perhaps the local residents would see how giving and loving Max is and receive him into their hearts and homes more readily.

He did a lovely job!

Max is happy and everyone loves him.

Thank you for helping us.

We both love you. <u>Me more!</u>

Love, Your friend

Debbie Reynolds

P.S. I hate to impose but would you sign the enclosed photos for me, for my home. I would cherish them. Or if you have another you prefer, fine—gratefully. Thank you.

Miss Hepburn was one of my idols. She was very reclusive, but she and Max wound up becoming good friends. I was thrilled when she sent me back a signed photo—and a note!

III-19-1986
Dear Debbie
 You did a really fine job that night. Any ass can handle a big crowd— But you just made a really tough situation work. Bravo!

 Kate Hep

Like most movie fans, I love having autographs from my favorite stars. I was always sending off pictures in the hope of getting them back signed. Many of them were portraits taken by Clarence Bull, the head of the photography department at MGM for many years. They were wonderful pictures—and expensive. I sent two or three beautiful Clarence Bull photos to Marlene Dietrich, at her suite at the Beverly Hills Hotel. She sent me back a lovely note each time, but no signed picture. I was happy to add to her collection, but that wasn't why I had sent them to her.

Miss Dietrich and I were never friends, but a star who was my friend used to do the same thing: Bette Davis. I sent

many Clarence Bull portraits of Bette to her to sign for me. She would always send me back a thank-you note telling me how lovely the picture was, and like Marlene Dietrich add it to her own collection. After a few tries with the expensive photos, I ran out of Bull. So I just sent a regular publicity shot, which Bette signed and returned to me. Now I find myself doing the same thing if a fan sends me something great that I don't have. I thank them and send them one of my publicity stills. Like Bette said, "Learn from the greats."

Speaking of Bette . . .

ALL ABOUT BETTE DAVIS

Bette Davis and Katharine Hepburn were the great actresses of my time. Now we have the marvelous Meryl Streep; but from the 1930s until her death in 1989, Bette dominated the acting scene with her many diverse performances. She was Warner Brothers' biggest star for many years.

In 1954 Bette took a lead role with Ernest Borgnine in *The Catered Affair* at MGM. The film includes my first dramatic role. Our director was horrible to me, as I wrote about in *Unsinkable*. Bette and Ernie, who play my parents in the movie, decided to protect me. They coached me on my scenes with them, which was wonderful training. Their reassurance meant so much to me.

After Eddie and I were married, we rented a house in the Pacific Palisades, a converted barn called All Hallows Farm. The place was rustic with a lot a farmland around it. Bette used to visit us there with her two children. B.D. and Michael were very young at the time, around eight and five, I think. Bette and I would walk outdoors with the youngsters while talking like girlfriends. She was married to Gary Merrill then but he never came with her. I believe they were having problems. In a way, he was like having another child for Bette; he required a lot of attention.

Bette had a funny habit: when you called her on the phone, she would answer in that distinctive voice, but overlaid with a foreign twist, pretending to be a French or Spanish assistant.

"*Allô*. This is Miss Davis's home. Who is calling?"

"Hello, it's Debbie Reynolds," I would answer, playing along.

"Just a minute. I'll see if Miss Davis is in."

Bette would put the phone down, pretending to go find herself. A minute later she'd be back on the line with a cheerful "Hello, Daugh-ter." (She always called me that after *The Catered Affair*.) Then we would settle in for a nice chat.

One of the impressions I do is of Bette. The audience always laughs when I walk along the stage using her signature tiny steps. When Bette saw my act, she was very complimentary. And she gave me notes on how to be her:

"It has to be bigger, more dramatic. Wave your arms around more."

After all, in a way I was competing with every drag queen who worked the stage in the 1950s and beyond.

Once the bell rang when I was getting things ready for a party at my home on Greenway Drive. I went to answer the door, and was surprised to see my first guest.

"Bette, you're an hour early," I said.

"Better early than late," she declared as she moved past me into the house.

She settled herself in a chair next to a table with an ashtray while I went about finishing up dressing and getting ready. She perched there all night, a cigarette in one hand and her drink in the other, as all our other guests arrived for the party. (Bette smoked constantly throughout her life. But in her dressing room when she was performing, the ashtrays were always empty, because visitors snatched her lipstick-stained cigarette butts for souvenirs. Luckily that didn't happen at my party.)

At one point in the evening, she asked me to show her the powder room.

"It's right there." I pointed out the nearest bathroom, but there was a line of people waiting to use it.

"I have to go *now*," she said.

She sounded serious. So I took her to use Todd's bathroom in another part of the house, and returned to the party.

Shortly afterward Todd went into his room and ran right into Bette, seated on his throne with the bathroom door open.

"Hello, Todd," she said, and proceeded to engage my eleven-year-old son in conversation while she continued her business.

In the early 1980s we were both hired to tape an awards show for the makeup industry at the Pasadena Playhouse, a beautiful old theater right outside LA. Bette was being honored and I was the emcee, appearing as myself and also doing my impressions of Madame and Miss Piggy. (It was the makeup industry, after all.) I had four introductions, which were all delayed because of my elaborate changes. During the first overlong break the singer Johnny Ray went onstage and performed one of his hits, which kept the folks entertained for four minutes. Bette got into the stalling act during another break, taking the stage to sing "I've Written a Letter to Daddy" from her 1962 horror film, *What Ever Happened to Baby Jane?* This delighted the crowd, who had been in their seats for hours.

At one point backstage, I asked Bette which dress I should wear.

"Make it a happy color," she advised, "because this night ain't it."

She was such a good sport. She sang and we sang together. It made the most ill-conceived show of a lifetime bearable. Thankfully it never aired.

On trips to New York, I would often visit Bette at home on Crooked Mile Road in Westport, Connecticut. We'd start with a tea service, like high tea in England, and gradually move on to wine or other drinks. Sometimes I'd spend the night. Roddy McDowell was another close friend of Bette's. He'd come to visit for a few days. They really loved each other. Eventually Bette gave up her Westport home for a condo in West Hollywood. She was like a marble mantelpiece from a great home that was now transplanted from a grand salon to a one-bedroom apartment.

Once I lost a personal assistant to Bette. Hal Martin idolized Bette. He knew every line she ever delivered in her many films, and was happy to leave me in the dust when she asked that he come work for her. Hal's typing wasn't great, but he had more important duties than just secretarial work. Bette would sit on his lap and make out with him, reciting her famous movie lines while they kissed. It didn't matter that Hal was gay. Bette found Hal lovable and really enjoyed kissing, and he was thrilled as long as he was near her.

..

Bette Davis was a classic. We were friends until she died in October 1989. I've always loved her, and didn't mind when she took away my assistant. I was happy because he made my friend happy. But sometimes you have to do more than be passive when a friend needs your help.

UNCLE RUDY

Rudy Render was my pianist and musical director for twenty-two years. He was also my very dear friend for much longer than that. I called him Uncle Rudy.

He was originally a friend of my brother's. They met when Billy and Rudy were both stationed at Fort Ord in Monterey. I used to entertain there on weekends when I wasn't on some date for the USO. Rudy accompanied me on the piano.

Once when they were on leave in the early 1950s, Billy brought Rudy for dinner at our house in Burbank. Mother and Daddy and I were sitting at the table when they arrived just in time to eat. Daddy looked at Rudy, got up, and left the room. Nobody had told him that Rudy was black.

"Daddy has an upset stomach," Mother explained, to cover for him.

She was terribly embarrassed about what Daddy had done. So were Billy and I.

After we'd all eaten and Rudy had left, we went to find Daddy in the garage, where he was repairing some machine. We asked him why he had been so rude to our guest.

Still concentrating on what he was tinkering with, he said, "I can take anything but not a n———." And he used a horrible word I won't repeat here.

"We can't live here if we're not free to have our friends," we told Daddy, and went and checked into a motel.

Daddy found us the next morning and we told him that we would not come back unless our friends were welcome no matter what color their skin was. That had been the original agreement in our family: any friend of Billy's or mine could come to our house as long as we lived with what Daddy could pay for and provide us. No color restrictions had been made.

I reminded Daddy about this, and he said that he would welcome Rudy in the future.

Rudy fractured his back in an automobile accident a few months later in LA. The doctors told him he needed a few weeks in bed. But he had no place to stay. Mother invited him to recuperate in our garage, which Daddy had recently converted to a guesthouse with a kitchenette and twin beds. Mother then nursed Rudy for three weeks.

I was out of town working, so Daddy was left to help her. He became so attached to Rudy that he considered him another son. Rudy felt the same way about Daddy.

During my first marriage, when Eddie was on the road, Uncle Rudy would spend the evening with me singing songs while he played the piano. Sometimes he'd stay over. He was there for me when my second marriage was falling apart, keeping me company until one or two in the morning when I needed him. He could always cheer me up.

Rudy was a respected musician who recorded for London, Decca, and Dot. In 1949 his single "Sneakin' Around," written by Jessie Mae Robinson, reached number

two on the *Billboard* R&B chart. He cowrote the title song for my 1959 movie *It Started with a Kiss*. Three years later he convinced me to do my own act in Las Vegas. Rudy and I worked together in the music room at my Greenway house. It was pure pleasure. He was a master of vocal arrangements.

In 1972 he gave up show business to teach public school. But he continued to advise me on musical matters and directed students in school shows. We always spent Christmas Eve together when I was in Los Angeles. He retired in 2001.

I was devoted to him, and would have done anything for him to show it.

Uncle Rudy and Bobby Short were first cousins. Bobby, of course, was much more famous. He played at New York's Café Carlyle for decades, from 1968 until 2003, two years before his death. Once, Uncle Rudy was filling in for Bobby, so naturally I went to see him play and sing. I was seated in the back of the small club, in a booth with one of the first ladies of the Broadway stage: Elaine Stritch. (She later became a resident of the hotel, she loved it so much.)

Elaine was drinking. A lot. As the wine flowed, she began talking while Rudy was performing. I tried to quiet her down. It was like trying to turn back a tornado. Elaine's voice wasn't soft either—she was once a stand-in for Ethel Merman. She could be heard throughout the room. After many attempts to silence the diva, I picked up the ice bucket chilling our wine bottle.

You've all been to the movies, so you know what happened next.

I dumped the ice and cold water all over her. This had the desired chilling effect: Miss Stritch shut up.

The next day I went to Saks Fifth Avenue and bought Elaine a beautiful silk dress to replace the one I'd ruined. I sent it to her apartment. She called me. She was very gracious, saying she loved the dress. But she never apologized to Rudy for talking through his show.

One of Elaine's best-known songs was a number she did in the original Broadway production of Stephen Sondheim's show *Company*, "Here's to the Ladies Who Lunch."

So here's to the ladies who stay quiet during cabaret acts!

...

Uncle Rudy died on September 11, 2014. I miss him. Here are some stories I haven't told before about two other dear friends who meant so much to me.

...

AVA GARDNER

In 1988 I went to London to promote my recently released book, *Debbie: My Life*. The publishers sent four of us on the trip: my mentor, Lillian Burns Sidney, who had worked very hard on the book; Kelly Muldoon, my hairdresser at the time; and my good friend Margie Duncan. We stayed at the Savoy Hotel.

It was an interesting mix of people. We were all a bit crazy in our own ways. Lillian was older, with all the troubles that go along with that. Margie is a gal from Philly who is lively and fun. Kelly thought she knew everything. We were all equally bossy, yet we were great friends.

One of the reasons I was happy to be in London was because my dear friend Ava Gardner lived there. She'd moved there in 1968. I looked forward to visiting with her.

In 1986 Ava had had a stroke that left her depressed and partially paralyzed. Her arm was twisted and it was difficult for her to speak. Lillian and I knew that Ava was embarrassed about her appearance but we didn't care. We were determined to see her.

Ava had a wonderful apartment in the Kensington section of London. She lived with her maid, Carmen, and a Welsh corgi she called Morgan. We took a magnum of chilled champagne, parked outside her building at Ennismore Gardens, and rang her bell. Carmen came down to the lobby, followed by Morgan, and took us upstairs to Ava.

We stayed for hours, drinking the champagne and reminiscing about our days at MGM when Lillian had coached all the actors at the studio. Ava was always sorry about her role in Show Boat. Although she loved playing the mulatto Julie La Verne, she thought that the part should have gone to Lena Horne, who was also under contract to MGM.

As the afternoon turned to evening, Ava became relaxed and happy. She even showed us some fabric that she was

going to have made into drapes. I didn't expect that her life would end just a few years later (she died in 1990).

Ava was so dear and so beautiful. She was one of our great stars. My brother, Bill, had been her makeup artist in 1985, when she had a running part on the hit TV series *Knots Landing*. At the very end, she was sad to lose her beauty. I went to see Ava a few years before she got sick. We spent a wonderful time visiting at her apartment, followed by a trip to her neighborhood pub for some drinks. She played Frank Sinatra's music on the jukebox the whole time we were there. She loved Frank to the end. Frank was good to Ava until the end, too. He helped her with her medical bills and other expenses. It was a shame when Frank left his first wife, Nancy, for Ava, but when a man wants to leave, he leaves.

ELIZABETH TAYLOR

"My life has had so many startling tomorrows that I don't think they've stopped," Elizabeth Taylor told an interviewer about a decade and a half before she died. Elizabeth was one of the biggest stars ever. She had an exciting life, a thrilling life. If Elizabeth saw something and wanted it, she got it. But she lacked that one special element that is normalcy, to be just a movie star loved in a relaxed and normal

way, without all the klieg lights going and not a minute when you're not onstage. In our early days as friends she often said that she felt envious of other young people who got to be real girls, not just movie stars. Who didn't always have to be "on," and got to enjoy being young and innocent.

Elizabeth's father, Francis, was an art dealer, very handsome and distinguished. He had that same great black hair, as did her mother, Sara, who looked like Laraine Day. The rumor on the MGM lot was that Elizabeth's mother was pushy. She was in on every meeting. She got a salary from MGM. Maybe that was because Sara herself had been a successful stage performer, on Broadway and elsewhere. She retired from acting when she married Elizabeth's father. Only her brother, Howard, a marine engineer, treated Elizabeth in a normal fashion. To him Elizabeth Taylor was simply his little sister. He loved her and she adored him.

I was fortunate when I first started at MGM. I got to go home to Burbank and have a normal life. Elizabeth went to University High in Los Angeles. They had an arrangement with the studio that underage contract players had to go there and pass an exam to show that they had completed their academic work. Even though I had finished at John Burroughs High School, I still had to pass that test. Afterward I was able to attend my high school basketball game with friends. Elizabeth just went to the MGM lot. I actually had a date for my prom. Elizabeth went to her prom with a date that was arranged for her. Still, she went

hoping to have a good time. She got all dressed up, gown and everything, and wound up signing autographs all night. It wasn't any fun for her. I doubt that she got one dance. It's no wonder that she wanted to have a good time later on.

It never changed, not even when she was sick and had an oxygen tube in her nose, or when she was finally dying. The press took pictures of her going into and out of the hospital, and every time, she had to have José Eber do her makeup. And Elizabeth was sick for nearly her entire adult life, ever since becoming pregnant with her daughter by Mike Todd.

The doctors warned her: "We doubt that the baby will make it, but you definitely won't make it, you cannot have this baby. Your back is so messed up we can't fix it. You can't put pressure on it like that."

But Elizabeth didn't listen. She adored Mike, and Mike was so excited that they were having a baby. And this adorable child came out. Liza looks like Mike, with Elizabeth's eyes. I've known her since she was born in August 1957, less than a year after I had Carrie. She's a beautiful girl and a very talented sculptress.

You could always tell how Elizabeth was feeling by her shoes. If she was happy and feeling well, she would be wearing pretty shoes. If she was sick, she wore slippers.

One night toward the end of her life I got a call from Elizabeth's French butler, Jean-Luc, who was with her all the time.

"Elizabeth hasn't had any visitors and she's very lonely,"

he told me in a hushed, soft voice. "She talks about you from time to time. She'd like to see you."

He asked if I would come visit her.

Elizabeth was still living in the Bel Air home on Nimes Road that she'd bought in the early 1980s. I had never visited her there alone. Carrie and I went once with Billie, for an Easter egg hunt. The grounds included a tropical garden and an English garden. A big In-N-Out burger truck arrived with food for the guests. By then Elizabeth was in very poor health. She was having back trouble and walking problems, and she never came downstairs. Everyone would go upstairs to see her. The green velvet drapes in the master bedroom were always kept closed. Even so, everybody had a good time.

Then I got lost on my way home. Bel Air is a dark, scary place at night. It's hard to see the street signs. I don't visit a lot with my friends at night anymore because of this.

I asked Jean-Luc if it would be all right for me to visit with Elizabeth on the phone. So we did that. I felt sad that I couldn't be with her.

In spite of her constant physical problems, Elizabeth loved to throw parties, especially on her "big" birthdays. To celebrate her seventy-fifth birthday in February 2007, she booked the Medici Cafe & Terrace at the Ritz-Carlton in Lake Las Vegas, seventeen miles east of the Strip. She invited seventy-five people for dinner with a Mardi Gras theme (jambalaya, prime rib, collard greens, sweet potatoes) and

cake. I didn't really want to go, especially outside Las Vegas. But Carrie really did want to, so we flew in together from LA.

Elizabeth arrived three hours late and in a wheelchair, but glamorous as ever, a vision in white. Floor-length, scoop-necked, long-sleeved white gown. A long white mink stole. A diamond collar necklace inset with three arced rows of huge pearls that covered most of the exposed skin above her bodice; matching bracelet on her right wrist and ring on her right hand; and matching dangling icicle drop earrings. Her short, jet-black hair and creamy white skin, combined with matching scarlet lipstick and nail polish on fingers holding a beaded white clutch bag, provided a striking contrast to her ensemble. She looked stunning.

All of her four children, now middle-aged themselves, were with her: Christopher and Michael Wilding, Liza Todd, and Maria Burton. The other guests included Kathy Ireland (Elizabeth's business partner in the House of Taylor jewelry line) and magicians Siegfried and Roy (their animals weren't invited). Aaron Spelling was there, as well as Nolan Miller, who'd designed all those over-the-top outfits for Joan Collins and Linda Evans in Aaron's 1980s show *Dynasty* as well as Elizabeth's dress for her party. Steve Wynn and his wife. Elizabeth's dear friend Michael Jackson, who had recently moved to Las Vegas, was nowhere to be seen, although his children came with their mother, Debbie Rowe—as did Michael's dermatologist, Arnie Klein.

Photographers sang "Happy Birthday" along with the

guests. Toasts were offered, and several of us made comments. I said something about Elizabeth and I having a very unusual friendship that had lasted all these years, and gave Elizabeth a Baccarat vase.

She stayed at her party only long enough to say hello to people, and then went upstairs to her suite with her children.

My last conversation with Elizabeth was shortly before she died. She had been in Cedars-Sinai for about six weeks. Everybody was very worried. I was in my house, and I thought, "I should call Elizabeth." I didn't know that she was really on the last lap. She didn't take calls, but she took my call. And we just made conversation. We made nice conversation.

"How's Carrie? How are you doing? How's your health?" she asked.

"How are *you* doing?" I said.

"Not too well, but I'm fighting all the way."

I couldn't help thinking that if someone looking like Richard Burton walked in right then, she would get well.

But it wasn't to be. Elizabeth became ill that night, and the next day—March 23, 2011—she died, with all of her children at her bedside.

I was sad when I heard the news, yet relieved. I loved Elizabeth. I never didn't love her. But I felt sorry that she never got to enjoy a normal life.

The year of Elizabeth's seventy-fifth birthday I needed a gown to wear to the Thalians ball, so I asked her to lend me the one she'd worn to her party. She sent it to me. I went to Nolan Miller's shop on Robertson Boulevard. Even though he was living at the Motion Picture Home, he came and altered it for me. (I still have that dress. I may have another ball to go to someday.) Here's a story about a Thalians gala where I wore another gown designed by Nolan Miller.

THE WOMAN IN WHITE

Every year the Thalians give a ball to honor a star. I had a hard time getting someone for the Thalians thirtieth anniversary, in 1985. Finally Lana Turner said yes to me. Lana had been one of MGM's biggest women stars, along with Elizabeth Taylor and Ava Gardner. It had been a couple of years since she'd had her featured role on the hit TV series *Falcon Crest*. The evening would be a tribute to her and her career—film clips from all her movies, an overture, everything.

Bob and Margie Petersen agreed to chair the gala in the ballroom at the Century Plaza Hotel. Bob was the owner of the Petersen Automotive Museum of vintage cars and motorcycles in LA, and publisher of many car-themed magazines such as *Hot Rod* and *Motor Trend*, as well as the fan magazines *Teen*, *Tiger Beat*, and *Sassy*. Margie ran the popular Scandia restaurant on the Sunset

Strip. Anthony Newley, the creator and star of *Stop the World—I Want to Get Off*, agreed to emcee; that year he also played the Mad Hatter in Steve Allen's all-star version of *Alice in Wonderland* for CBS. Comedian Rip Taylor agreed to serve as our auctioneer. And Jackie Cooper, Danny Thomas, Robert Preston, Marvin Hamlisch, George Hamilton, Charlton Heston, Red Buttons, and Hal Linden would tell anecdotes about Lana.

The evening arrived. Among the celebrities in the audience were George Peppard, Tony Danza, Barbara Eden, Alex Trebek, Robert Stack, Lloyd Bridges, Zsa Zsa Gabor, Cesar Romero, Robert Culp, Jack Haley Jr., and Rhonda Fleming. My daughter, Carrie, was there as usual, and so was Lana's daughter, Cheryl Crane, her only child. Cheryl was with her girlfriend, a beautiful woman. I was so startled; I'd never known that Cheryl was a lesbian. And then I was happy, because they seemed so happy. They were a lovely couple.

Another thing I didn't know until that night was that Lana was famous for not showing up.

She was supposed to arrive at 7:00 P.M. Her apartment was only five or six blocks away. Time passed and we were all waiting. No Lana.

So I called her.

"I'm getting ready, dear, doing my hair," she said.

She had a young hairdresser—a really tall gay guy with white-blond hair; she was his friend until the end of her life.

More time passed. I called again.

"I'm just having a problem with my hair, dear. He's making it more silvery. I'll be a little late."

I kept calling, and she was still getting ready. And every time I called she was onto a "second" glass of wine. Lana could really drink to make herself happy. She was a very highly strung friend. She wasn't like Ava Gardner. Ava was very down-to-earth, and not nervous at all. (No wonder Frank couldn't win.) Lana was the opposite. She was very girlie and very feminine and very enchanting. She reminded me a little of Marilyn Monroe: sexy and girlie and childish. She adored men and she beguiled them. But now wasn't the time for her to be getting drunk.

I asked to speak to the hairdresser.

"Are you guys drinking?"

"We're just visiting, just talking," he said.

I was upset, because he went along with her. He knew she had to get there. He should have opposed her drinking. Instead, he was having a good time with her.

"You have to get ready and come over right now," I told him.

He said they would.

Finally it was 8:30. Showtime.

"I don't think I can come," Lana said when I called. "I'm just too tired."

You bet I was angry. We were friends at MGM all those years, and she couldn't get herself the few blocks to her own tribute?

"Listen, Lana," I said. "You need to get your ass over here. I'm coming to pick you up."

I got in the car and went to fetch her. Lana and the hairdresser had their coats on and were ready when I arrived. They were both smashed.

When we finally got to the Century Plaza, we were so late that the press had left. We went in through the back door, just in time for Lana to receive her award.

Even though she was drunk, Lana looked divine. She had on all her jewelry; a formfitting, glittering white-beaded gown; and a white fox cape around her shoulders with white fox tails hanging off the end. She was dazzling; simply spectacular. As she was walking—*very carefully*—to the microphone, one of the tails right behind her ass fell off, onto the floor. Rip Taylor was standing nearby. He picked it up and handed her tail to her. I'd been so angry with Lana, but then I started to laugh. It was like retribution.

So Lana never saw the tribute to her—not that she would have seen much anyway, she was so drunk.

She came to the party at the hotel afterward with Cheryl, still smashed, and met with people and was charming and gracious. And we all laughed about it.

It was quite a night and quite a tale—or should I say *tail*.

...

Speaking of "tail" . . .

A DATE FROM A BABY DOLL

When I was in New York performing in *Irene* in the early 1970s, Carroll Baker came to visit me. We had become friends when we made *How the West Was Won* together a few years before. Carroll's most famous role was as a sexy young bride in the 1956 film *Baby Doll* written by Tennessee Williams and directed by Elia Kazan. It earned her Academy Award, Golden Globe, and BAFTA Award nominations.

When she saw me, Carroll became concerned. I was going through so much at the time. My second marriage, to Harry Karl, was over. I was depressed, had lost all our homes, and was unsure about the future. I had been working so hard that my weight had dropped to ninety-eight pounds.

Carroll thought I could use some cheering up, and arranged for me to go out on a date.

When I opened the door to greet him, I was a bit taken aback. The young man looked about the same age as my son, Todd, who was then around fourteen. But he seemed sweet and we had reservations for dinner, so off we went.

We had a nice time together. The conversation was pleasant. I resisted the temptation to cut his food and wipe his face.

When we got back to my town house, I said good night

as I tried to give him money for the dinner check that he had paid.

"Oh, no. I'm prepared to stay the night. I'm a gift from Miss Baker."

Needless to say, I politely refused this boy toy's offer. I hope that Carroll got her money back.

..

In case you're wondering, Carroll lives in New York now, where she spends her time with her grown children, Herschel Garfein, a Grammy Award–winning musician, and Blanche Baker, a very talented actress.

Sorry for going off script. I believe I was speaking about the Thalians? Every year when we do the Thalians ball, I always invite my friends. It's important to have stars attend these events. Here's one I wish hadn't come.

..

LUCK OF THE DRAW

Shelley Winters was a pain in the ass. She gave me headaches every day when she costarred in my 1971 movie *What's the Matter with Helen?* Even so, I coaxed Shelley to come to the Thalians ball, going so far as to offer her a free ticket. She gave me a rough time but finally agreed to attend.

For many years Bob Petersen donated a car to be given

as a prize in a drawing. That year he gave us a new Buick or Lincoln. We put everyone's ticket stubs in a bowl and I drew the winner.

When I read the number, we all heard a big scream. It was Shelley. I was so mad. She hadn't even paid for her ticket! And she was rich, rich, rich, having bought up several streets of property in Beverly Hills.

After the show I went to Shelley and asked her to donate the car back to the Thalians so we could raise money for the hospital.

"No!" she said emphatically. "Why would I do that? This is the first thing I've ever won."

Shelley was a character, to put it mildly. She once locked herself out of her Beverly Hills house while she was wearing only a nightgown, and just asked someone who stopped to help to drive her to the studio. Later on, her family tried to put her away, claiming she had dementia. She told the judge, "I may act nuts, but I'm not nuts. I'm just amusing."

Very.

..

One of the original Thalians was also one of my dearest friends. Our charity raised millions of dollars for mental health. We wanted to give back something to the community that had been so generous to us. But we had many other things in common.

A KINDRED SPIRIT

Sometimes people come into your life who feel like you've known them forever. That's how I feel about Jack Haley Jr. We were such good friends because we shared so many common interests. His father played the Tin Man in *The Wizard of Oz* with Judy Garland, so Jackie was raised in the Hollywood studio system. Jackie's best friends were David Niven Jr. and Tom Mankiewicz, and the sons of studio heads Darryl Zanuck and Sam Goldwyn.

Jackie loved the movies. He showed his love to the world when he produced the 1974 film *That's Entertainment!* The movie helped make it possible for screen musicals to be produced again. Film preservation and the love of performers were part of his family heritage. He owned lots of movies and had a room in his house for editing. I loved these things from the outside first, and then from the inside after I was lucky enough to get into the business.

Over the years Jackie and I shared our love of collecting and preserving Hollywood history. He bought a lot of memorabilia, some from the 1970 MGM auction and some from other sources. He was on many of the boards of organizations that worked to establish a Hollywood museum. He owned a red-and-white outfit that I wore in a dance number with Marge Champion in *Give a Girl a Break*. He even had costumes from *Gone With the Wind*.

When I opened the small Hollywood memorabilia museum

in my Las Vegas hotel, Jackie asked Tom Mankiewicz to lend me the sled Rosebud from Orson Welles's great movie *Citizen Kane* to display. Tom's uncle, Herman Mankiewicz, wrote the screenplay for this most famous film.

When I performed in casinos and nightclubs, I changed from getting up before dawn to make movies to being a night owl who went to bed when the sun was rising. I'd finish my last show around 11:30 P.M. I knew I could call Jackie at all hours to talk, and so I spoke to him on the phone almost every night after my show. Or should I say, early morning.

Sometimes he would be asleep when I called.

"Wake up, Jackie," I'd say. "Put your feet over the side of the bed on the floor."

I'd wait to hear him moving out of bed.

"Do you have to pee? I'll wait till you're done."

Once I had gotten Jackie out of his dreams, we'd visit on the phone for an hour. We could tell each other anything.

Eventually Jackie asked me not to call him after 2:00 A.M. Then I was cut back to 1:00 A.M. When we reached 11:00 P.M., I switched to calling him earlier in the day, *before* my shows.

Jackie loved going to premieres and parties. When *Superman II* was released, in 1980, he asked me to go with him to the opening. He was also taking Altovise Davis, Sammy Davis Jr.'s wife. He was very close to the Davises. Sammy was on the road so much that Jackie would often escort Altovise to events.

After the screening, there was a party at a big house

on Doheny Drive above Sunset Boulevard. The mood was festive. This was the age of "sex, drugs, and rock and roll," which I missed on all three counts. Bowls of cocaine were set out in plain sight. A big tree had pot hanging from it—you just plucked off a joint and smoked it. But if you didn't smoke or snort, it wasn't fun.

When I went into the powder room, a young man followed me, a very handsome Italian man who was at the party with one of the producers. Before I knew it, he had slammed me against the wall and was trying to rip my clothes off. The guy was really smashed, not just drunk. Whatever he was on was very strong. I thought Superman had jumped off the screen and onto me. I got in a few swift kicks. You could hear me scream all the way to Malibu.

Jackie and three other big men came in and pulled him off me. Then Jackie drove me home. That was the last premiere I went to with him until the opening of my film *Mother* many years later.

Jackie died in 2001. I went to his house after he was gone and took rocks from his front and back yards as mementos. I still have them outside my kitchen door. They remind me of my dear friend every day.

..

My friends in the Thalians are very giving people, and not only through our charity. One of them gave me a sweet experience I wouldn't have had otherwise.

..

A BELATED THANK-YOU NOTE

In June 2007 I was invited to attend the premiere of *Jersey Boys* by Robert Ahmanson. He and his son Bill were friends I met through the Thalians. The Ahmansons were very successful businesspeople and philanthropists.

Jersey Boys is a sensational show. I was on my feet hooting and cheering through the first act. At intermission I saw Frankie Valli in the aisle a few rows in front of me, so I went over to congratulate him on the show.

"Isn't it wonderful? I'm so thrilled for this great success," I told him.

Frankie thanked me and introduced me to the handsome young man standing next to him.

"This is Eddie Murphy," he said.

"Oh, hello. I'm Debbie Reynolds."

I always introduce myself to people when I meet them. Folks tend to mix me up with Connie Stevens or Doris Day.

"I know, I love you," Eddie said. "I'm a big fan of yours."

"I love you, too. I'm your fan, too. I love your work."

What a treat to meet this talented comedian. I've always admired him, first on *Saturday Night Live* then in his many movies. A fan came up to Eddie, asking for his autograph. Eddie graciously agreed, asking for a pen. The fan didn't have one and neither did Eddie. I did. I reached into my purse and handed my pen to Eddie. Eddie signed the program for his fan—and kept my pen.

The next afternoon, a huge bouquet of gorgeous flowers arrived at my house. And I mean *huge*—at least four feet across and equally high. The card with the flowers read:

Sorry I kept your pen. I loved meeting you.
Your devoted fan,
Eddie Murphy

There was no number on the card, so I called his office, but was never able to thank him personally.

So, thank you, Eddie. I adore you. I appreciate that beautiful gift. I still have the vase on my front porch. You're a class act.

...

And thank you, Bob, for taking me to *Jersey Boys* and for being my friend. Bob passed away just three months later, in September 2007. He was a lovely person who gave so much to so many through his family foundation.

Now let me tell you about two of my closest longtime friends who are still with us.

...

THE CONSTANT SHOPPER

In 1955 Eddie and I spent part of our honeymoon at the Thunderbird Hotel in Miami, Florida. While we were there

we got to know the owners, Albert Pollak and his wife, Phyllis. We became friends with the Pollaks and would see them whenever we were in Miami. Phyllis and I especially became great friends.

Phyllis is such fun to be around. She's so energetic. When she visits me now, out of nowhere she'll drop to the floor and do a set of push-ups. And she's ninety!

She taught me a lot about antiques. (Phyllis collected French Provincial antiques, among other styles.) I grew up in a family with a long history of loving junk. Before Mother and I started going to thrift shops, Daddy used to take Billy and me to junkyards—usually a piece of land with wire fencing around it, owned by an old man who didn't care to mingle with society. There were bicycles and tires and screws and all kinds of things. Later, when I was hired by Warner Brothers, I met a woman named Miss White whose house was furnished with some French objects with inlaid wood designs that I liked very much. She explained what they were, and I realized that I wanted to know more. Phyllis loved to shop and had lots of practice. I was eager to learn whatever she could teach me.

Whenever Phyllis and I are in New York together we go to antiques stores. Once we spent an afternoon shopping on Fifty-Seventh Street. A beautiful S-shaped conversation seat in one window caught Phyllis's eye. We went inside to talk to a salesperson.

"How much is this?" Phyllis asked.

"Thirty-five thousand dollars."

"Do you have two?"

"Madam, you must understand that this is a very rare piece. It's the only one of its kind in the world."

"And you must understand that I have a very large living room. So I need two of them."

End of discussion; Phyllis thanked the man and we moved on to the next antiques store.

On that trip we were sharing the two-bedroom presidential suite on the top floor of the Essex House. In the elevator with us when we got back to the hotel was a gentleman who left it on a lower floor. Once inside our suite, we started to unpack our purchases in the living room. A few minutes later the phone rang.

"Hello?" Phyllis answered.

A deep breathy voice responded.

"I saw you in the elevator. I want to put my cock in your mouth. I want to feel your lips all over..."

Phyllis put her hand over the mouthpiece.

"Debbie, it's for you."

I went and took the phone from her.

"Hello, it's Debbie."

"I saw you in the elevator. I want to put my cock in your mouth. I want to feel your lips all over—"

I hung up without hearing any more, and joined Phyllis laughing.

I love New York. People really speak their minds there.

In April 1958 Eddie was performing at one of the Miami hotels and of course we spent time with Phyllis and Albert. One afternoon Eddie and I passed a gallery that had a life-size portrait of Elizabeth Taylor in the window. We both thought it was a beautiful painting. Eddie's birthday was coming up in September, and I decided to commission the artist, Ralph Wolfe Cowan, to paint my portrait as a surprise gift for him.

I went back with Phyllis to order it.

Unfortunately, Eddie left me before the paint was dry. He heard that Elizabeth's portrait had never been claimed, bought it as a gift for her, and left me for the real thing. (I found out about his buying the portrait from the newspapers, which got the story from Ralph. One paper even ran a photo of my portrait with the headline "Rejected." Many also carried stories on the same page about Eddie and me separating.)

When my painting was finished, I called Ralph to tell him I didn't want it, even though I'd already paid for it. I was trying to get rid of things that reminded me of our failed marriage, not add to them. Ralph sent it to me sometime later anyway. That was very nice of him. It's so beautiful that I've had it hanging in my living room for many years.

So, ladies, if you're reading this remember: when you're thinking of a birthday gift for your husband, buy something that you can return—in case he doesn't.

Getting back to Phyllis, did I mention that she loves

shopping? She often visited me when I was on the road. When I was performing in *Irene* in 1973, she came to New York. One afternoon while roaming around Bloomingdale's she spotted a handsome man who looked familiar. She got closer, and realized it was Bob Fallon, an acquaintance of ours from Hollywood. Bob had recently lost his wife, Marie Wilson, an actress most famous for her pinup qualities.

Phyllis moved right in.

"You know Debbie Reynolds, don't you?"

"Of course."

"She's living in New York now, doing a play. Why don't you come by for a drink?"

Phyllis has excellent taste. I'd just gotten a divorce from my second husband and she thought Bob would be a nice man for me to date—which turned out to be true. We hit it off right away. He also hit it off with my Diner's Club card. From day one he lived beautifully on it. But he was the first lover I really enjoyed having sex with, and he treated me well. He was wonderful company. We went on cruises to Italy, Australia, and Bali, and stayed together for about eight years.

Unfortunately for me Bob was also a player who felt the need to screw every woman he met. He really believed that it would hurt their feelings if he didn't have sex with them. Whenever Phyllis found a pair of panties lying around my dressing room, she automatically asked Bob if they were his.

Hey, nobody's perfect. In many ways he was ideal for a match made at a department store.

I have to admit that Phyllis is better at matchmaking than I am. While I was in Hawaii shooting the pilot for my short-lived 1981 TV series, *Aloha Paradise*, Phyllis came with me. One of the men at the resort we stayed at asked me on a date. His name was Lloyd Berkett. I went out with him only once because all he talked about was tennis and golf. After our date, he asked Phyllis for one. Albert had died years before, as had Phyllis's second husband.

"You can't go out with him," I insisted. "He's a total bore."

Phyllis enjoyed playing golf, and said she'd have dinner with Lloyd.

"Make sure he's attentive to you. He's asking everybody out on this island. Don't be nice to him unless he gives you a present of some kind."

They've been married for thirty-four years now.

..

..

SHE'S MY FRIEND

Aside from being a sperm bank, Eddie Fisher was good for something. His friend from Philadelphia became my friend for life.

Margie Duncan knew Eddie in high school. When I met her, she was a dancer in New York City at a theater called

the Versailles. Eddie took me to see a show she was in, then out to dinner with Margie and her boyfriend Bernie Rich, Eddie's best friend from Philly. They'd all been performers on a local radio show there as preteens. Margie and I were wearing the same outfit. We looked like sisters even then.

Bernie and Margie got married around the same time Eddie and I did. Their first son, Michael, was born October 20, 1956. When Margie went into labor, Eddie and I were in Palm Springs. I was close to having our first baby, so my doctor went to the desert with us. I called Margie when she was in the delivery room; we told the hospital that Debbie and Eddie were on the phone for her. They actually carried a big telephone into the delivery room so we could talk.

"How does it feel?" I asked Margie.

Her screams were answer enough. She didn't need to put it in words, and if she did I couldn't hear them.

After we hung up, I felt a pain. The doctor and Eddie thought I was going into labor.

"No, it's just sympathy pains for Margie," I told them.

Then I had another pain.

The doctor confirmed that I was in labor.

We got into the car and drove back to Los Angeles. My daughter, Carrie Frances Fisher, was born the next day, October 21.

More babies arrived and several years passed. My son, Todd, was born in February 1958 and Margie's son Mark

was born three weeks later. She had one more baby, a little girl named Elisa.

We both had traumatic divorces and we both kept going. When Margie was on her own again with children to support, she found a job. Most recently, she had worked for several costume designers, including Bob Mackie and, later, Paul Whitney, who had a store on Sunset Plaza Drive in Hollywood.

Margie came to visit me with Elisa in 1963 when I was getting ready to do the film of *The Unsinkable Molly Brown*. We talked about the movie. Margie told me that Paul Whitney had just closed his shop.

I got an idea.

"Why don't you come work on the movie with me?"

I had just gone through a stillborn pregnancy and needed a "dance-in." A "dance-in" is a dancer who works out a number with the choreographer in place of the star until it is set. They then teach it to the dancer who will perform it on-screen. The girl who was usually my film "dance-in" had just gotten married and her new husband wouldn't let her work. (It *was* 1963—the good old days when married women were housewives and mothers and that's all.) I needed a replacement, and knew Margie could do it.

"Oh, I couldn't," she said, surprised. "I'm so out of shape."

"So am I," I told her. "We'll get back into shape together."

Margie reported to the studio to work, and was told that

they already had my dance-in. They'd hired someone else to work with me without my knowledge. They started to show me my part with a person I'd never met.

"Where's Margie?" I asked. "She's supposed to be doing this."

They explained that Margie had gone home because she wasn't needed.

"Well, when Margie learns the number, I'll be back."

As the song in *Molly Brown* says, "She's my friend." I'd promised my friend the job and I stuck up for her.

Margie started getting frantic calls from people at the studio who said they'd been looking for her for days. Margie had been home with her children the whole time, so she knew they were just trying to cover their asses. She came in to work and learned the number and several others.

Peter Gennaro was the choreographer on *Molly Brown*. His routines were tough but terrific. He really worked us to capture the wild times in the Gold Rush era when the story takes place. In the opening dance number, Molly sings that she "Ain't Down Yet" while climbing a thatched-roofed building, walking along the roof, stepping backward on the side of the roof, then back to the top again. During rehearsal Margie and Peter kept dancing on the rooftop to set the number. On the last try, one of the straw shingles came loose. Margie toppled off the roof, over a log on the ground, and into the dirt. She wasn't hurt but those shingles were nailed down by the time I showed up.

In rehearsal for the famous "Belly Up to the Bar" routine, Margie was doing the number where Molly gets everyone up to the bar. When she had to jump onto the bar, every dancer in the company volunteered to lift her because there was a pay bump for dancers who did lifts. Someone suggested that there be glasses for the bartender to pull back when Molly lands on the bar. On their first try at this new business, a dancer named Alex Plasschaert gave Margie a kick in the face with his cowboy boot. Everyone was concerned. But Margie didn't complain, even though she was seeing stars.

The next day, Margie showed up for work without a mark on her face. The assistant director was our friend Hank Moonjean, who worked with me on several of my films, including *The Catered Affair*. He had an idea for a joke. The makeup man would do some special makeup on Margie so it would look like she had really been injured. He put a bruise on her face and even created a split-skin effect. When director Chuck Walters came in, he took Margie's chin in his hand and looked at the mark.

"That's not so bad," he declared.

Everyone concurred, including me when I got to the set.

The only person who felt bad was Alex, who thought he'd put his boot print on Margie's cheek. Margie finally confided in him that it was makeup, put there as a joke.

When I no longer had dance-in work for Margie, I hired her to be my assistant. In 1979 I bought a former post office

to house DR Studios and put her in charge of the daily operations while the workers were building the rehearsal spaces. She still runs DR Studios, which is a big success.

To this day, Margie continues to be the sister I never had, a most loyal friend, and the gatekeeper to my business.

9

.

Family Matters

When people ask Carrie what it was like growing up with famous parents, she usually responds, "Compared to what it was like when I grew up with *other* parents?" My own upbringing was very strict, and it was difficult to raise my kids in a world that was so different from the one I knew as a child. But I am blessed to have exceptional children, and somehow we managed!

..

SEE YA LATER, ALLIGATOR

Animals have always been an important part of our family's lives. We usually have dogs but sometimes we have more exotic pets. My daughter-in-law, Catherine, is very attached to her pet rooster, Nugget. On the ranch that she shares with my son, they have animals of every description.

When we lived on Greenway Drive in Beverly Hills, the back of our house was right up against the Los Angeles Country Club. There was a small lot behind the house where the kids played.

One of our housekeepers left us to move back to Florida to live with her family. She sent Todd a small alligator as a present. Todd was only about seven or eight at the time, and he was thrilled with his new pet. We got an aquarium for the little reptile. I thought it would stay little, like the small turtles you can keep as pets in a glass bowl.

Todd's alligator began to grow . . . and grow.

Before long it outgrew its little tank. (I say "it" because no amount of coaxing could get me to check under an alligator's tail to see if we should paint its room pink or blue.) After a series of larger and larger glass tanks, we decided to let the alligator live in the bathtub for a while.

It was growing at an astonishing rate.

Soon we realized that the alligator would have to be relocated. Todd was upset. He cried and cried about losing his friend, who was becoming large enough to have Todd for lunch.

My husband Harry intervened, offering Todd a hundred dollars for his pet alligator. This just made Todd more upset as the reality of losing his slimy buddy set in. It also upset Harry, who thought that anything could be handled with cash.

Our security guard, Zinc, was given the task of taking

care of the alligator. Zinc loaded Todd's pet into the back of the station wagon and took off. I didn't ask any questions.

Life post-alligator went back to normal. Todd didn't say much about his pet. None of us thought much about it again.

One morning there was a blurb in the newspaper about golf balls disappearing at our neighboring golf club. No one could figure out who was stealing all the balls from the course. A few days later, the paper mentioned an alligator sighting at the club.

Oh, dear.

Soon after that, news broke that the staff at the club had captured the alligator with an appetite for golf balls. The paper said it was going to live at the LA Zoo.

Most exotic creatures are better off in the zoo. Except for Lady Gaga.

...

...

CURSES!

Warning: This section contains language that may not be suitable for young audiences.

When I was growing up, there was no swearing in our house. When my daddy accidentally cut off the tip of his finger in the woodshop and blood was gushing all over, all he said was "Damn." Then, motioning toward the fingertip on the

floor: "Go pick that up." We went to the doctor's to get it sewn back on, but Daddy always had a crooked finger after that.

When I became a parent of young children myself, in spite of all that went on in our house, I never swore in front of them. And I never used dirty words.

When Todd was eight or nine years old, his friend John Courtney dared him to swear in front of me, to see what my reaction would be. Todd told John that I would never put up with it. John convinced Todd that I wouldn't punish him, and my son decided to try me.

That afternoon I was busy setting the table for a dinner party in the evening. Todd came into the dining room and let loose with a string of obscenities. Without missing a beat, I raised my arm and backhanded him without turning around.

"You don't do that," I said.

Todd just stared at me, then went into the kitchen with his friend John and said, "See? I told you she wouldn't take it from me."

He was happy I hit him. I was so upset that I started crying after he left the room. I had never slapped my child before, but I felt his behavior needed to be corrected.

Todd and John just went on playing.

One day I picked Carrie up at school. She got in the car and said, "Mom, someone wrote the word *F-U-C-K* on the handball court. What does it mean?"

"I'll tell you later when I can draw you a diagram," I answered.

Needless to say, I never drew that picture for my little girl. I don't have the artistic ability to draw a picture like that . . . or the memory.

When she was around fourteen, *asshole* became one of Carrie's favorite words. One night at the dinner table, she kept using that word over and over. Finally I reached the end of my patience.

"Say it one more time and I'm going to leave," I warned her—like that was a threat to a rebellious teenager.

In response, Carrie mouthed the word *asshole*.

So I stood up, clutching the buttons of my robe at the neck, and walked out of the room. At least she saw that I was serious.

When Carrie was seventeen she was cast in her first movie, *Shampoo*. Warren Beatty was the cowriter, producer, and star. He plays a Hollywood hairdresser who has sex with every woman who will let him. Warren himself was a famous womanizer. He is the brother of my friend Shirley MacLaine. I first met him when he tried to pick me up while I was under a hair dryer at MGM, reading a book. He lifted the lid, said he'd always wanted to meet me, and asked me to have dinner with him. He was in his early twenties and had already broken Joan Collins's and Leslie Caron's hearts, among others. I was between husbands, but I wasn't about to be his next conquest.

"You're a very forward young man," I said.

"Age has nothing to do with it," he responded.

"No, thank you," I said, and sent him on his way.

Now my daughter had shown up with a script in which her character was supposed to have an affair with Warren. Even worse, her character instigates it. Carrie's first words to Warren are "Wanna fuck?"

I told Carrie that I objected to her using that word.

"Mother, I say 'fuck' every day," she said. "It's no big deal to me."

She begged me to let her do the movie, and I knew I had to. It was important for her to be more than just the daughter of Debbie Reynolds.

Carrie told Warren about our conversation and he called me. I told him I would prefer it if he had her character say something else.

"How about 'screw'?" he suggested with an edge to his voice.

"Okay, how about it?" I said.

"Because it won't work for the script. 'Fuck' is 'fuck.'"

"Maybe it isn't just the word, Warren," I admitted. "Maybe that's not what's bothering me. You know Carrie is very mature for her age, but she's really just a child."

He said I was being ridiculous and Victorian.

"That's what I am."

"No, you're not, and she isn't, and you can't hold her back. She's anxious to do this and she'll be damned good."

He promised that he would only be her producer and her uncle, that he would pick her up every morning and bring her home each evening. And he did. Carrie would fly

out the door a very excited young girl, being picked up and brought home by her gorgeous producer. She has assured me for many years she was unscathed, as you might say.

A couple of years later, Carrie and I were in London, where we performed together at the Palladium. Someone cursed at me as we were walking down the street.

"Did you hear that, Carrie?" I said. "That fucker just used the f-word."

Carrie looked at me in shock.

"Please stop swearing around me," I said, "because I'm starting to use those words myself."

When I was younger I felt that it wasn't necessary to use curse words. If you want to use colorful language, find another, more creative way of expressing yourself. It still upsets me when someone takes the Lord's name in vain. I don't tolerate that to this day. I'm a square and always have been. But now that I'm older, I realize that sometimes you need a good cussword to make a point.

A TRICKY DICK

Around the time of Watergate, Carrie and I were invited to the White House. President Nixon had been elected to a second term in 1972 but there was a definite dark cloud over his administration. Carrie was sixteen. She wasn't

interested in politics, and some of her friends had explained President Nixon's troubles to her. When I told her we were going to visit the president, Carrie's reaction wasn't subtle.

"*No!* I won't go," she cried.

"We're going. It's a chance to visit our First Family's home."

"I won't go. No. No. No."

Neither one of us remembers what I did to bribe or threaten her to visit the president.

Carrie and I dressed very nicely, me in a coatdress and she in a velvet dress with a high lace collar. We had a short visit. It was in the winter, so we didn't get to see the Rose Garden. Although Carrie is smiling in the pictures that were taken, she wasn't a happy girl.

President Nixon sent us each an autographed picture. Carrie's was signed "To Carrie, May all your dreams come true." She said she wanted to write him back a letter saying "I dreamt that you were impeached." Thank goodness she never got around to it.

Carrie had another encounter with Nixon when she was recording one of her audiobooks. Both she and the former president were working with the same producer, who took word back to Nixon that she was working with Carrie. Nixon sent Carrie another picture, this one with the inscription "For Carrie—from one of her fans, Richard Nixon."

Today those pictures of President Nixon are proudly displayed in her bathroom—right next to a framed picture of

the front page of a New York newspaper with her wedding picture with Paul Simon.

The first time I met Richard Nixon, he was President Eisenhower's vice president. Nixon arrived at the Burbank airport, where I was waiting to present him with a scroll that made him an honorary member of my Thalians charity.

In February 1973 I was touring with my Broadway show *Irene* before we opened in New York. We had already taken the show to Toronto and would be heading for Philadelphia, then on to Broadway. That was a bumpy ride for me. Sir John

Here I am making Vice President Nixon an honorary member of my favorite charity, the Thalians.

*Carrie had to be dragged kicking and screaming to
her visit with President Nixon. Now she keeps a copy of
this picture displayed proudly in her bathroom.*

Gielgud was our director and the show wasn't working. We were getting bad reviews. I finally hired my old MGM friend choreographer and director Gower Champion to replace Sir John, and things began turning around.

While we were in Washington, DC, President Nixon came to see the show, along with his entire family. Afterward they came backstage. The president not only complimented us on the play, he predicted that it would be a big hit on Broadway. He was very gracious to the entire cast, taking time to greet everyone individually.

I may have mentioned to him that I would love for

my daughter to have a tour of one of our nation's most important places, and that was how we got that invitation. She didn't want to go, but when she did, she wound up with a souvenir picture for her bathroom she wouldn't have otherwise.

So if you are ever invited to visit the White House, you really should go. Who knows what you might get out of it!

UNEXPECTED MEETINGS WITH GREAT WOMEN

A few years ago I was in New York with Carrie.

"You want to stop off at Bette Midler's? She's having a party," she said, on the way back to where we were staying.

"I'd love to," I said.

Bette has a beautiful penthouse apartment with a winding staircase up to a big terrace overlooking Central Park and the city. The gathering was informal. She had great music playing. I remember a lot of books and a lot of laughs. Carrie and I enjoyed ourselves with the other guests.

At one point a woman came up to me and said, "I'm John Saxon's sister."

In 1958 John and I had starred together in the Universal movie *This Happy Feeling*. Forty-six years later we did A. R. Gurney's two-character play *Love Letters* at the El

Portal Theatre in North Hollywood. I liked working with him. Now here was his sister. I was delighted to meet her; I wish I could remember her name. I was so fond of John.

Miss M really is one of our great performers. I heard Bette on Jimmy Fallon's show recently talking about keeping chickens on her penthouse roof. She said she named the little cluckers after the Kardashians.

That may qualify as poultry abuse.

Thinking about unexpectedly attending Bette's party with Carrie reminds me of another gathering I went to that I never dreamed would happen, also with a family member: my mother.

Sydney Guilaroff was one of the greatest movie hairstylists of my lifetime. He worked on hundreds of films, making the beautiful actresses even more glorious for the screen. He was a genius at creating the right looks for the many parts we played. Sydney himself was the most elegant man. He dressed in a white coat with a white necktie while he worked with all the great MGM stars—Garbo, Hepburn, Crawford, Elizabeth Taylor; they all adored him. My children called him Uncle Sydney, as he was as close to us as any member of our family. In the wonderful 1939 movie *The Women*, all the ladies in the film go to Sydney's Beauty Salon for beauty and dishing. This was so named for Mr. Guilaroff.

Sydney stayed friendly with all of us. On one occasion when we were in New York in the early 1970s, he asked a

star he'd worked with at MGM if he could bring me to a dinner party at her apartment. I immediately asked Sydney if I could bring my mother along, and was thrilled when he told me the hostess had said yes.

I knew Mother would love meeting the legendary Greta Garbo.

For everyone who loves the movies, Greta Garbo is one of the most cherished stars. In addition to being a great actress, she had mystique. Famous for the line "I want to be alone" from her 1932 movie *Grand Hotel*, she really did prefer to live outside the glare of the Hollywood limelight. She gave us other wonderful films like *Camille*, *Anna Karenina*, and *Ninotchka* (directed by the great Ernst Lubitsch). Her last film at MGM was *Two-Faced Woman*, released in 1941. She was very unhappy with it and retired to New York. She was only thirty-six. After making twenty-eight films and being nominated three times for the Academy Award as Best Actress, there was no "good-bye" or farewell party, no "Thank you, Miss Garbo" or "Good luck, Miss Garbo, thanks for all the movies." She just vanished to the East Coast to live a quiet life out of the public eye.

But she did have many friends who kept her company, and Sydney Guilaroff was one of them. Another was financier George Schlee, who lived in the same building as Garbo with his wife, Valentina, a famous couturier who designed dresses for Garbo and Katharine Hepburn and other prominent stars.

Mother and I were staying at the Plaza Hotel. We were so excited as we got into a taxi with Sydney to go to Garbo's building at the end of Fifty-Second Street overlooking the East River. We were welcomed into a spacious living room. All of Garbo's furniture was Louis XIV and other European antiques. She had tapestries, Aubusson rugs, and beautiful crystal. I was in heaven.

The evening was very quiet and formal—and frightening for me. I was used to Hollywood parties where Sammy Cahn played the piano while Judy Garland, Frank Sinatra, Nat King Cole, and any other guest who could carry a tune got up and performed. At least the dinner itself was informal, even though the party wasn't: a buffet with lovely food.

The guests all ate sitting around the living room and den of the seven-room apartment. Garbo spent the evening close to the floor, sitting on a rather large, square ottoman. I understand this was her preference, even at other people's gatherings. She sat upright, holding her head high, rather in profile, and didn't seem to get tired. She was still quite beautiful, even though she was in her sixties. Mother and I sat on the very comfortable couch. I had a good view of the antiques, which I loved.

After visiting for a little while, we said our good-byes and thanked Miss Garbo for a lovely evening. I didn't ask for her autograph, although I was itching to have one. I wasn't that rude.

The evening is vivid in my memory. It was like meeting

a queen. I felt awestruck and privileged to be there. I knew I would never see her again. Sydney was very gracious, as was Miss Garbo to receive me, and especially to extend the invitation to my mother, who was certainly someone she couldn't have cared about meeting. I was so happy she didn't tell Sydney "I want to be alone." My mother was thrilled as we all went back to the Plaza Hotel and called it a most unforgettable night.

..

..

TWO PRINCESS LEIAS,
A TAP DANCER, AND TWO BULLDOGS,
OR, "SAY GOOD NIGHT, DEBBIE"

Being in show business isn't as easy as it looks. When I was young I planned to go to college to become a gym teacher, even after I'd made several movies, first at Warner Brothers and then at MGM. People at the studio thought I was crazy. Since then, I've proven them right. After a few years it became clear that performing was the right career for me. I was having such fun. Still, after more than sixty-five years and countless ups and downs, I understand what my daughter meant when she said, "Celebrity is just obscurity waiting to happen."

Carrie and I disagreed about almost everything when she was growing up. She was never interested in doing

anything I wanted her to do. (I guess in that respect she was a normal teenager.) Carrie has a beautiful singing voice—strong and deep like her father's. So of course she chose acting. When I insisted that she attend school to learn how to act, she fought me. So she auditioned for the London Central School of Speech and Drama, won a scholarship there, moved to England, and stopped talking to me for two years. I'd send her friends to visit her in London. They got a wonderful vacation and I got news about my daughter. I thought that was a good exchange.

Carrie wasn't crazy about growing up as a movie star's child, and I guess it's fair to say that being my daughter was sometimes tough on her. There were perks, of course, but there were also problems—really big ones. Her father left us for Elizabeth Taylor when Carrie was only two years old. She would sit by the window waiting for him to come home. Fortunately Carrie doesn't remember how the world turned its glaring spotlight on our family. Years later, when Carrie was grown up and Eddie and Elizabeth had long ago gone their separate ways, Carrie confided to Elizabeth that she'd resented her for all the time she didn't get to spend with Eddie. "You didn't miss much," Elizabeth replied. When I did *Irene* on Broadway, Carrie was in the chorus. Doing the musical was a way for me to work through the nervous breakdown caused by divorcing my second husband. I told Carrie all about Harry Karl's affairs and gambling, and how he'd

bankrupted our family. It was a lot for a teenager to deal with.

My son played a Cub Scout in one of my television specials, *Debbie Reynolds and the Sound of Children*—not a big stretch for a ten-year-old boy. But that was enough for Todd. Afterward he wanted nothing to do with acting. Seven years later I took him to see Yul Brynner's 1976 revival of *The King and I*. Todd kept asking questions about the technical aspects of the show. He wound up being interested in lighting, sound, and especially production—but still in show business.

Other stars have children who chose to follow them into this crazy business. Tom Hanks's son, Colin, and Tippi Hedren's daughter, Melanie Griffith, have both done very well as actors. Melanie's daughter with Don Johnson has also grown up to be an actor; Dakota Johnson is the female lead in the movie *Fifty Shades of Grey*. (I'm doing the senior version—*Fifty Shades of Grey Hair*.) Michael Douglas is as famous now as his father, Kirk Douglas, was at the height of his career, while Jeff and Beau Bridges may be more famous than their father, Lloyd Bridges, was at his height. Martin Sheen also has two famous actor sons, Charlie Sheen (who might better be called infamous) and Emilio Estevez (who graduated from being a member of the Brat Pack to being uncontroversial). Meryl Streep's daughters Grace and Mamie are both well-regarded actors now, and Bette Midler's daughter, Sophie von Haselberg, is in Woody Allen's 2015 movie, *Irrational Man*.

So I suppose I shouldn't be surprised that my grand-daughter, Billie Lourd, is playing a small role in *Star Wars: Episode VII–The Force Awakens.*

Carrie says now that she wouldn't have taken the part in *Star Wars* if she'd known how it would affect her life. It made her world famous at the age of eighteen, but to many people she will always remain Princess Leia, no matter how many other things she's excelled at and accomplished. Her daughter is handling being in a *Star Wars* film well. Billie has already graduated from New York University and is very talented with the piano and guitar. She is grown up but to me she will always be my little granddaughter. I used to sing "Aba Daba Honeymoon" (my first hit song) to Billie when she was a toddler, and ever since then she's called me "Aba Daba" instead of "Grandma." She went from diapers to cute little dresses to a galaxy far away.

My dream was to have a healthy, beautiful grandchild. It came true when Carrie gave birth to Billie in July 1992. I wanted to help raise her but I was always on the road and the years have passed all too quickly. I could never have enough time with our Billie. I didn't know what she would want to do after she finished college. Now that she has a small part in the new *Star Wars* movie, her heart's been opened and she's interested in acting (ironic, since Carrie was so upset about being a movie star's daughter). Billie is lovely, talented, sweet, and gracious. She's her own person,

doing what she wants. In spring 2015 she began acting on TV in *Scream Queens*. Carrie and I are so proud of her.

I guess it makes sense that we would one day wind up working together in the family business.

Las Vegas has been a big part of my life since the 1960s. As movie roles went to younger actors and my MGM days came to an end, going from musicals to concerts was a natural way to earn my living. I've more or less been on the road ever since. Now that I'm in my eighties, I want to sit down and smell the roses. There's no way I want to do a whole ninety-minute show anymore.

I'd been booked for a three-day engagement in early November 2014 at the South Point Hotel and Casino for a while before I made this decision. As the date approached, I asked if I could do two days instead. They weren't having it. Michael Gaughan, the owner, has been very good to me, as was Roy Jernigan, the entertainment director. Michael hired me for many years when he was with the Orleans Casino. Now he wouldn't take no for an answer. Besides, all three shows were sold out. I couldn't get out of doing it but I was happy about that at least.

So I called on my family for help, and Carrie and Billie agreed to share the stage with me. My usual soundman had another job, so Todd agreed to set up my sound system. Hopefully it would be a nice way to end my Vegas days.

Carrie was just finishing shooting *Star Wars* the week

before my engagement. She flew in from London on Monday knowing we would have to leave for Vegas on Thursday. Billie flew in from New York around the same time. I was frantic. None of us knew what we would be doing. I worked out a new rundown for the show. Carrie planned to sing "I'll Never Say No to You" from *The Unsinkable Molly Brown*. Billie said she would like to sing a duet with Carrie—the number I did with Eddie Fisher in *Bundle of Joy*. Then Billie would do a contemporary song on her own. Now we only needed to find a time when we were all in the same place, to rehearse. Packing, singing, flying, every one going every which way. We finally made it to Vegas.

That weekend the South Point Casino was also hosting a rodeo in their equestrian center. I arrived in the huge hotel lobby at the same time as every cowboy within a five-hundred-mile radius of South Nevada. There I was, little Debbie in the middle of mobs of people in cowboy hats and spurs, carrying lassos and sporting number tags on their chests, amid huge posters everywhere of me in a beaded Bob Mackie gown.

We started the sound check on Friday afternoon at 3:30. Backstage was chaos. A friend of Carrie's was filming a documentary about our family. Carrie and Billie had their pet bulldogs with them. We worked hard on our cues, staging, and the lighting to prepare for opening night.

At 7:30 the showroom was full. I took the stage hoping for the best, dressed in my gold bugle-beaded evening

gown. I sang and talked for thirty minutes, then played clips from some of my movies, ending with a number from *Molly Brown*—Carrie's cue to enter from stage right singing.

> *"I'll never say no to you,*
> *Whatever you say or do.*
> *I'll smile if you say, 'Be glad.'*
> *I'll cry 'cause I'm bipolar.*
> *Today is tomorrow*
> *If you do lots of blow.*
> *I'll stay or I'll go,*
> *But I'll never say no."*

"Ladies and gentleman, my daughter, Carrie Fisher," I told the audience, but they were already applauding. They didn't need the introduction.

Carrie went on to tell everyone how happy she was to be onstage with her mother again. How I'd forced her to be in my act when she was only fourteen. Then she talked about the movie I made with her "alleged father," Eddie Fisher.

"They made *Bundle of Joy* while she was pregnant with me. She did all those dance numbers—which accounts for my mental deformities."

"You had such a wild young life, dear," I said. "Was it because of the blow?"

"No, it was the acid."

(Did I tell you that my daughter only feels normal when she's on acid?)

As Carrie continued talking, Billie appeared at stage left singing a jazz riff of "Lullaby in Blue" from *Bundle of Joy*. She walked upstage to stand next to her mother and me. Then Carrie sang with her.

"How I love my pretty baby.
Sweet and precious little baby.
How I love my pretty baby
Honest to goodness I do."

After that, Billie sang a beautiful version of Etta James's classic "At Last"—my granddaughter's solo singing debut. Then Todd entered from stage left, singing "Oh my Ma-ma, to me she was so wonderful"—a slightly altered version of his father's big hit record "Oh! My Papa."

We all bantered back and forth, then ran some old home movies I had taken with the 16mm Bell & Howell camera given to me when I was a guest on *This Is Your Life* in 1961. Then we sang two rousing verses of "There's No Business Like Show Business" and I closed the show with my hit song "Tammy."

The audience was wildly enthusiastic throughout. It was wonderful to have my family with me as I bade a modest farewell to my Vegas days. Now I'll have more time to spend with them—if they're ever in town!

It feels like I'm coming full circle with my children and grandchild. Todd is settled with his new wife, the beautiful

actress Catherine Hickland, and busy doing sound-engineering work. Carrie is acting and writing. I believe her best work is still ahead of her. I still kid myself that someday she may be a singer. Billie is grown up and likes to wear my old clothes—they're "vintage" now, and I never throw anything away. She just shortens the skirts. So now she has closets full of fabulous Bob Mackie gowns and classic designer outfits. It's a thrill for me to see her in them. I pray I'll be here to see her fly. I'll always look after her, even if it's in a heavenly way.

Happy Mother's Day 2015

*I*n April of this year, I called a friend.

"Guess what!" I said cheerfully. "I've got great news."

"What is it?" she asked.

"I've got irritable bowel syndrome."

After what seems like an eternity, my condition was finally diagnosed. My friend and assistant Donald looked up my symptoms on the computer. We asked the doctor to order the test, which finally led them to this conclusion. After all the doctor visits and the stay at the Mayo Clinic, Donald was able to help them find out what was making me sick.

I was euphoric. God willing, I can get out from under this and feel better.

At this time in my life I'm working to figure out my future. I like the idea of being retired, but I also like to be

onstage entertaining my wonderful audiences. My heart wants to sing and dance but my health sometimes knocks me down.

You may wonder how movie stars spend their holidays. Don't believe the Hollywood version of Mother's Day where Joan Crawford is sitting in her beautiful yard in a chiffon dress and a broad-brimmed hat surrounded by her adoring children calling her "Mommie dearest."

My version of Mother's Day this year would never make it to a greeting card. My son, Todd, and his wife, Catherine, planned to come down from his ranch for the weekend. Todd arrived around 3:00 P.M. on Friday with his fourteen-year-old Australian shepherd, Yippee. Catherine arrived around 5:00 P.M. with her pet rooster, Nugget, age unknown.

Friday evening was uneventful. Carrie was next door with her daughter, Billie, who was home from being on location for her new show, *Scream Queens*. On Saturday afternoon, Todd went somewhere to look at a camera he wanted to buy. Carrie came over to visit with me, while Catherine was out in the backyard with Nugget. My dog, Dwight, was sound asleep.

This calm scene was interrupted by a loud splash and strange spitting sounds coming from my bathroom. When I built my little house, I put in a spa bathtub that is actually a small indoor swimming pool. It's very therapeutic when I

have back trouble. It measures about eight by ten feet across and is about four feet deep—more than enough depth to drown my son's loyal companion, who is blind, deaf, and has trouble with his legs.

Frightened by the noises coming from the room, I rushed in to find Yippee yelping and terrified in the water, helpless. He must have gone over the side while trying to drink from it. Why couldn't he drink out of the toilet like a normal dog?

Yelling for Carrie, I went down the four steps into the warm water, picked up Yippee under his front paws, and put him over my right shoulder. I was tits-high in the spa water holding poor Yippee, who seemed to be in shock. Carrie came in waving her phone and yelling. All I could hear was Yippee's spluttering, which let me know he was still alive. Carrie got behind my left shoulder to hold me while I was holding the dog. Her phone went in the drink. We were both soaking wet in our clothes, trying to get this poor critter out of the water and onto the bathroom floor.

Catherine appeared in the doorway and stood there, frozen in her tracks, just saying "Oh" as she watched Carrie and me haul Yippee out of the pool.

Carrie yelled for my housekeeper, Rena, to bring her a bowl of uncooked rice so she could save her phone as we dragged Yippee up over the edge of the tub and laid him on my bathroom floor—eighty pounds of wet Australian

shepherd on my tiles. We got some towels to wrap him up. Yippee was still spitting out water, but at least he was breathing. My daughter-in-law continued to just say "Oh" and look like a deer in the headlights.

Meanwhile in the backyard, Billie's dog, Tina, was scheming to get Nugget out of his cage. Nugget is a well-cared-for rooster whose only problem is being near the bottom of the food chain. Tina is cute but I'm sure she's on a terrorist watch list somewhere. Todd came home just as Tina was about break through Nugget's wire cage.

In my bathroom, Catherine had finally come out of her trance enough to help us get Yippee dry. We put towels down on my bedroom floor, right on top of the beautiful carpet the shah of Iran gave me. When the dog was out of danger, Carrie turned her full attention to her phone, which had all her notes for her new book in it.

Just then Todd walked in and saw us huddled over his best friend.

"Anything happening?" he asked.

Once we'd told him, Todd took Yippee outside to recover and decompress.

Donald came home from getting his car inspected to find Rena grabbing at my wet clothes, trying to clean up the soaking towels in the bathroom, and helping Carrie. I slipped into a dry outfit and got into my bed to catch my breath.

After all the commotion died down, Billie and her

boyfriend stopped by. She needed clothes for a press event for her new role as a Scream Queen. She found four outfits in my closet and was thrilled to go off to New York in my vintage clothes.

Everyone returned to their respective rooms. Nugget and Yippee were out of harm's way. I smiled to myself as I savored the rare quiet moment.

"Shtick," I thought, "always shtick."

I've spent my whole life being a vaudevillian, a baggy-pants comedian.

Thank goodness.

But as Mae West said, "Goodness had nothing to do with it."

Acknowledgments

My memories are full of the wonderful times I've shared with my children, Carrie and Todd. In bad times, they make me laugh through the tears. In good times, we are thankful for all our blessings. Maybe someday my extraordinary granddaughter, Billie Catherine, will share these stories with her children. They should know just how much fun we had in our day.

When I decided to write this book, I knew I could never do it alone. My dear friend Dori Hannaway is one of the funniest people I know. She helped me pull this book out of thin air by listening to my stories, asking lots of questions, and writing so well. Thank you, dear, for making all this work fun.

Donald Light and Margie Duncan continue to be devoted friends. We've all been through so much together. I'm so grateful to have you in my life.

Thanks a million, Dan Strone, my fantastic literary

agent at Trident Media. I never would have done this book without your persistence in believing that there were more stories to be told after my memoir *Unsinkable*.

Jennifer Brehl, my editor at William Morrow. Thank you for your attention and support. It was a pleasure to work with you again.

Debbie and Dorian thank:

Rick Hersh of Celebrity Consultants.

Jackie Triggs of Trident Media.

Kelly O'Connor at William Morrow.

Thanks to the team at Morrow: Elissa Cohen, Michele Corallo, Lynn Grady, Brian Grogan, Doug Jones, Tavia Kowalchuk, Emin Mancheril, Shelby Meizlik, Michael Morrison, Joseph Papa, Mary Ann Petyak, Jeanne Reina, Beth Silfin, Liate Stehlik, Mary Beth Thomas, and Nyamekye Waliyaya.

Thanks to Renato Stanisic for his beautiful book design.

Special thanks to everyone who helped us by sharing their recollections: Margie Duncan; Donald Light; Pinky Bajian, Gary Simmons, Sandy Avchen; Phyllis Berkett; Jeanette Johnson, Jean Powers, Keith Alavolasiti, Don Rickles, George Schlatter, Ben Mankiewicz. And Carrie and Todd Fisher.

At the Academy of Motion Picture Arts and Sciences, thanks to Randy Habercamp, May Haduong, and Claire Lockhart.

And thanks to the Academy's staff at the Margaret

Herrick Library, especially Faye Thompson and Libby Wertin.

For their help with reading the manuscript and giving us their most welcome corrections and changes, thanks to Michael Miller, John Kalish, Dori Stegman, Donald Light, Cary Fetman, Nikki Smith, Tom Wilson, Carol Hannaway, Ken Sweigart, Dr. Joanne Steuer, and John Hazelton.

Thank you to everyone who helped with the many questions we had as well as with the many details. Abe Gurko, Mike Hannigan, Karla Thomas, Kathy Connell at the SAG-AFTRA Awards, Kenny DiCamillo, John Sala, and James Moore.

Many people helped with the wonderful photographs: Ron Mandelbaum and Howard Mandelbaum at Photofest; Manoah Bowman, Bill DiCicco, Lee Hale, Phyllis Marcotte, Jim Pierson, Matt Tunia, Greg Vines, Frank Vlastnik, Dan Wingate, and Stan Taffell.

And very special thanks to:

Tom Wilson. For a know-it-all, you're still a nice guy. We appreciate your expertise as an entertainment historian and archivist. Thanks for sharing your amazing photo collection.

Carol Hannaway for her expert digital imaging and photo restoration on Debbie's photographs.

And our wonder worker behind the scenes, our editor, Patrick Merla, for making everything sing.

INDEX

Note: Page numbers in *italics* refer to illustrations.

About the Authors

Debbie Reynolds, often referred to as "America's Sweetheart," is an actress, comedienne, singer, dancer, and author best known for her leading roles in *Singin' in the Rain* and *The Unsinkable Molly Brown*, and on television as Bobbi Adler in *Will & Grace*. After more than sixty years in the entertainment industry she is truly a Hollywood icon. Today, she continues to thrive, performing her one-woman show around the world, making film and television appearances, and writing a syndicated weekly advice column. She lives in Beverly Hills, California, and Las Vegas, Nevada.

Dorian Hannaway, coauthor with Debbie Reynolds of the bestseller *Unsinkable*, was the director of late-night programming at CBS for more than fifteen years, supervising the production of *The Late Show with David Letterman*; *The Kids in the Hall*; and *The Late, Late Show* with three

hosts: Tom Snyder, Craig Kilborn, and Craig Ferguson. In 2010 she produced *The Battle for Late Night*, a two-hour documentary for A&E. She has known Debbie for more than thirty years, and has written and produced many projects with her.